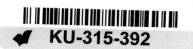

ABSTRACT
A WORLD ELSEWHERE

DAVID ANFAM

EXPRESSIONISM

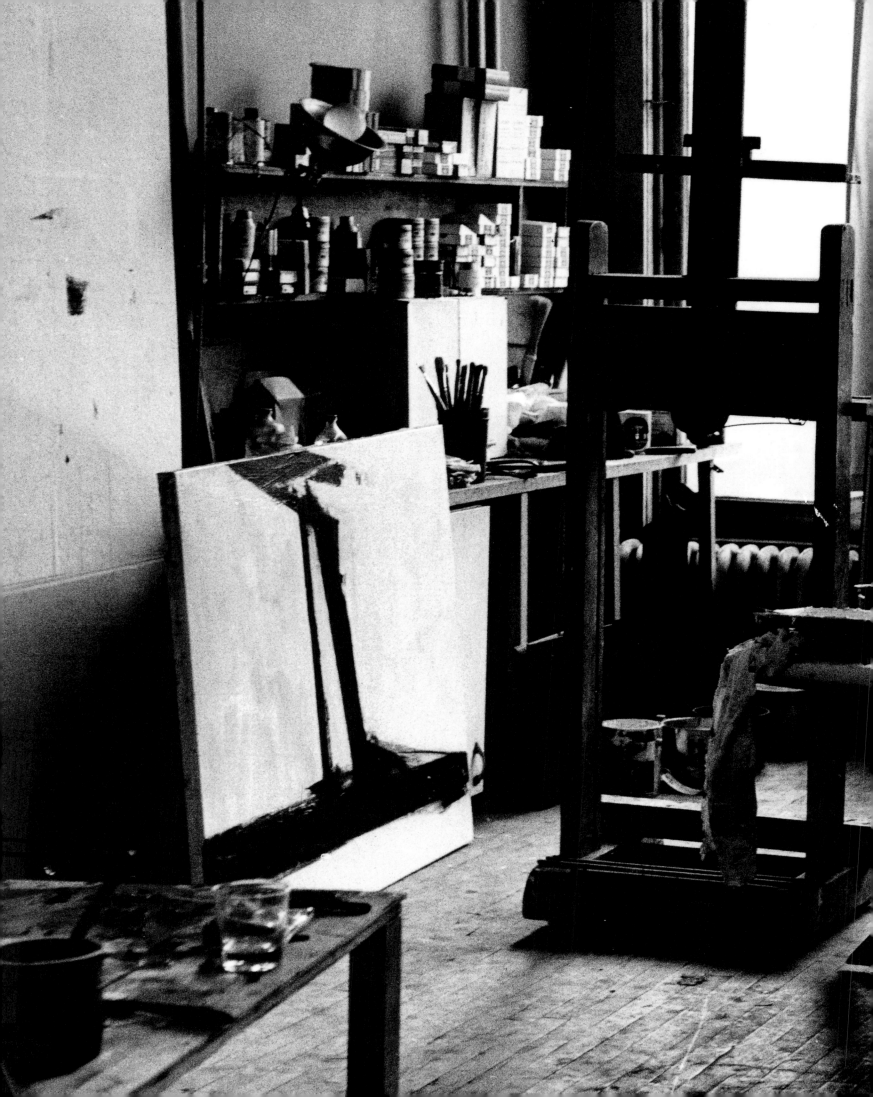

ABSTRACT EXPRESSIONISM
A WORLD ELSEWHERE

09.12.08—11.12.08

HAUNCH OF VENISON

FOREWORD

Harry Blain, Robert Fitzpatrick
and Graham Southern, Directors
Haunch of Venison

There have been many astonishing moments during the recent history of art in America, but one of the most central and significant took place with the birth of what became known as Abstract Expressionism. It's a movement whose artists and works are so familiar to us today that we think the voyage of discovery has been completed — until key works are brought together and we find ourselves in the midst of a conversation that is still lively and intense, rather than merely an echo of the past.

With some acknowledged impudence, we decided to open Haunch of Venison's Manhattan gallery with a fresh look at this very important historical moment for the arts in New York. The endeavor may seem counter-intuitive for a contemporary art gallery whose flagship is in a seventeenth-century London courtyard, but the concerns that Abstract Expressionist artists explored remain just as pertinent and problematic today as they were 50 years ago. And by opening our new gallery at Rockefeller Center in the symbolic heart of Manhattan, we wished to acknowledge that Haunch of Venison had arrived at a different place with a different history, in a world elsewhere.

As a new participant in the cultural life of New York, we hope to make an important and engaging contribution to the city's museum and gallery-going public by paying homage to the American birthplace of post-war abstraction and providing a fresh look at the history, texture, and unparalleled influence of this single art movement.

Abstract Expressionism — A World Elsewhere is a major undertaking by any standard, but is not meant to be an exhaustive survey of Abstract Expressionism, nor to make any claims for New York's exclusivity when it comes to abstraction in the mid-twentieth century. Indeed, West Coast abstraction is prominently featured in the exhibition.

Outside the US, other art movements with similar goals and approaches, such as Spatialism in Milan, Tachisme in Paris, and COBRA in Copenhagen, Brussels, and Amsterdam, were occurring at about the same time, adding to the rich fabric of post-war abstraction. However, it was the New York School that set a new course for art not only in America but internationally, which is why we chose to focus on it.

Abstract Expressionism — A World Elsewhere is curated by the art historian and pre-eminent scholar on post-war American art, David Anfam. The exhibition borrows its title from the classic work of literary criticism *A World Elsewhere: The Place Of Style In American Literature,* published in 1966 by the American critic Richard Poirier, and takes Poirier's emphasis on freedom from societal constraints, nonconformism, and social protest in American literature as its rubric for reconsidering the (r)evolution of abstraction in America and its subsequent impact. The show aims to provide an integrated examination of this defining esthetic moment in the history of American art by including a selection of drawings, collages, prints, and photographs alongside major paintings and sculpture from public and private collections. It also presents a reconsideration of the Abstract Expressionism canon from an outsider — a British curator with a commanding knowledge of, and innovative perspective on, the subject.

Through unanticipated juxtapositions, the exhibition instigates and invites new conversations about Abstract Expressionism by providing diverse points of access concerning formal relationships in the work, personal relationships among the artists, and philosophical points of view. The curator's gift to us is the joy of surprise and the delight of discovery as you walk from one gallery to the next: from a moment of shock by way of pairing a late figurative painting by Philip Guston with an archetypal abstraction by Clyfford Still, to moments of grace in the delicate balance of works by Barnett Newman, Robert Motherwell, David Smith, and Franz Kline. Anfam's astute selections invert our expectations and challenge preconceived notions about Abstract Expressionism through provocative contrasts in scale, color, surface quality, and motion —

from the dynamic activation of canvases in works by Willem de Kooning and Lee Krasner to the meditative quiescence of spartan abstraction in works by Newman, Ad Reinhardt, and Jack Tworkov. Additionally, with the inclusion of artists such as William Baziotes, Richard Pousette-Dart, Norman Lewis, and Charles Seliger, redressing the exclusion of under-recognized proponents of Abstract Expressionism in its history, the show provides the opportunity for a wide-ranging comprehension of a more richly multifarious and layered movement than we have known before.

We would like to thank all the lenders who have generously agreed to part with their works for the duration of *Abstract Expressionism — A World Elsewhere*. Without the vital support and co-operation of these museums and private collectors, who are listed elsewhere in this catalog, our exhibition would have been impossible to realize. Most particularly, we owe a debt of gratitude to David Anfam, whose scholarship, connoisseurship, and passion has inspired us at every stage of the exhibition's development, and whose essay opens new avenues for understanding these important artists and the phenomenon in which they were caught up.

A WORLD ELSEWHERE

David Anfam, Curator
Abstract Expressionism —
A World Elsewhere

I paint only myself, not nature — *Clyfford Still*

I *am* nature — *Jackson Pollock*

The classic American writers try through style temporarily to free the hero (and the reader) from systems, to free them from the pressures of time, biology, economics…. They tend to substitute themselves for the world — *Richard Poirier*

For better or worse, Abstract Expressionism has grown familiar. Nowadays the art, its makers and their legacy seem, to experts and the general public alike, almost ubiquitous. An ever-growing body of testimony might cite the increasingly commonplace posters and sundry reproductions of Mark Rothko's paintings;[1] the popular Hollywood film released in 2000 about Jackson Pollock (besides his appearance, as well as Rothko's, two years before, on United States postage stamps); recent big biographies of Arshile Gorky and Willem de Kooning, with a further tome on David Smith underway; the building of a museum in Denver devoted solely to Clyfford Still's estate; grand catalogues raisonnés on virtually all the leading œuvres, most lately Barnett Newman's;[2] well-worn academic debates over whether the movement was a tool of American imperialism during the Cold War or, by contrast, an undertaking engaged in timeless myth and symbolism;[3] soaring auction records; retrospectives on a nearly annual basis for one or another of the leading stars; and a current exhibition treating the New York School's two critical champions, Clement Greenberg and Harold Rosenberg.[4] In short, Abstract Expressionism's familiarity has bred the proverbial content and maybe even, in some circles, a modicum of contempt. Intellectually, it is often savvy to elevate the alternative tradition of Marcel Duchamp's conceptual irony over Abstract Expressionism's romantic sincerity.[5] Nevertheless, any account of art since 1945 must recognize the latter — whether as an influence or, inversely, something to resist — as foundational. In contemporary parlance, Abstract Expressionism caused a paradigm shift.

If we are liable to regard Abstract Expressionism as a closed chapter, that possibility alone should be one good reason for taking a fresh look. True, the shock of this art's newness faded long ago. We can never regain the zeitgeist in the late 1940s when, say, President Truman thought modern painting 'looked like scrambled eggs' or an American senator furiously excoriated it as communist propaganda.[6] That our very notions of what constitutes 'art' have changed a lot since then partly reflects Abstract Expressionism's seismic heft. The use of monochrome and monumental proportions, the concern with the body and its dynamics, the dissolution of sculpture into space, signs or environments, the pursuit of spirituality and absolutes, explorations of the psyche and of individual identity and the survival of painting itself comprise just a few of the issues that Abstract Expressionism has helped to lodge into mainstream artistic practice. Like any worthy classic, Abstract Expressionism is large enough to possess a perennial lure — a text to which successive generations inevitably bring their own new readings, insights and misprisions.

To mount a comprehensive survey of such a subject would pose a challenge for many a museum, if not downright folly. While the quality and significance of the pieces on display has always remained paramount, *Abstract Expressionism — A World Elsewhere* does not attempt comprehensiveness, despite being an ambitious venture. Furthermore, it is indicative of an evolving, brisk cultural climate in the twenty-first century, when boundaries between the ivory tower and the market place, creativity and commerce, are increasingly porous, that a private gallery backed by an auction house should enable what was planned from the outset as a scholarly endeavor (nothing is for sale). Ironically, some museums today might not have had the resources to meet the expense of insurance, transportation, conservation, photography, travel, manpower and other costs associated with assembling more than 60 paintings, sculptures and photographs — a number of them iconic in themselves and from major institutions and distinguished collectors in the United States, Canada and Europe — by 28 artists.

Then again, could a single show do justice to Abstract Expressionism anyway? Doubtless not, because it is a sprawling phenomenon with contested definitions/borders and changing consensuses, or none, about the participants at stake. Accordingly, a prudent curatorial agenda ought to address the protagonists generally acknowledged as central — Franz Kline, de Kooning, Newman, Pollock, Rothko, Still & Co. — while also encompassing various members of the first generation who are sometimes ranked, unfairly, as arguably more peripheral. Among the second roster here are William Baziotes, Arshile Gorky, Adolph Gottlieb, Philip Guston, Hans Hofmann, Robert Motherwell, Richard Pousette-Dart, Ad Reinhardt, Charles Seliger (a remarkable figure, too, in being among the last survivors of that heroic era) and Jack Tworkov. Furthermore, since revisionists began expanding the canon in the 1990s, Abstract Expressionism's 'outsiders' — women, blacks and homosexuals — have become entrants in a broader scenario that open-minded scholars ignore at their peril.[7] Thus, given the intrinsic caliber of their finest creations, Lee Krasner, Joan Mitchell and Norman Lewis deserve a decisive place in the present show.[8] If numerous additional luminaries are absent — James Brooks, Richard Diebenkorn, Conrad Marca-Relli, Bradley Walker Tomlin and Theodoros Stamos in particular spring to mind — the viewer should know that it reflects less merit than the practicalities of Haunch of Venison New York's spectacular, while of course still finite, space.[9] In this respect, simple physical limits have sometimes serendipitously solved by fiat the complex interpretative question of whom to include/exclude.

Since the mid-1980s when writing *Abstract Expressionism* (1990), I have felt convinced about the need for perspectives that go beyond painting to discern deeper affinities during the American 1940s and 1950s with sculpture, photography, literature, poetry, music and dance. After all, David Smith avowed that he belonged with the painters: hopefully, visitors may enjoy discovering his sculptures in these galleries in dialog with their two-dimensional kin. The Solomon R. Guggenheim Museum's Smith retrospective (2006) also confirmed, if proof were needed, that he had a matchless range, virtuosity and imaginative powers. This judgment need not detract from his noted coevals: Herbert Ferber, Ibram Lassaw, Seymour Lipton, Theodore Roszak, and so forth. Yet the latter band have perforce had to yield to the expressive scope — extending from massy painted steel to delicate glinting silver, witty figurative totems to stern abstract glyphs [pls. 50—55] — that only a substantial representation of Smith can fulfill. Likewise, Louise Nevelson's absence may raise eyebrows. However, last year the Jewish Museum surveyed Nevelson in depth.

Surprisingly, New York City has not witnessed an overall presentation of Abstract Expressionism in different media since Henry Geldzahler's mammoth *New York Painting and Sculpture: 1940—1970* at the Metropolitan Museum of Art 38 years ago. Geldzahler in any case covered much else besides.[10] Similarly, Robert Hobbs and Gail Levin's path-breaking *Abstract Expressionism: The Formative Years* happened at the Whitney Museum of American Art as long ago as 1978 and had a cut-off point of 1949, while the Metropolitan's *Abstract Expressionism: Works on Paper* (1993) stuck to graphics from in-house holdings.[11] Instead, New York has hosted myriad retrospectives — from Kline (1994) and Rothko at the Whitney to Pollock at the Museum of Modern Art (both 1998) and lately Smith at the Guggenheim — rather than any substantial group survey combining the disparate players. It is time to start rectifying the oversight.

Regarding the selection of photography, how could Aaron Siskind — who moved in the social circles of the Abstract Expressionist painters, showed in the same galleries and created a posthumous homage to Kline [pl. 48] — ever have been kept apart by historians of the movement? Some of Siskind's photographs [pls. 48—49] delve the inchoate blackness that Still and Motherwell also plumbed; others echo the cryptic ideograms in Gottlieb's Pictographs or Kline's graffiti-like rawness. Nor is there any doubt that Barbara Morgan's work [pls. 24—25] belongs to the under-appreciated genre of 'action photography' — Hans Namuth [pl. 30] being another prime practitioner — that in the 1940s shared common ground with, and probably directly influenced, the enactment of motion, gesture and trace in the paintings of Pollock, de Kooning, Kline

and others.[12] *Mutatis mutandis*, Morgan's photograms curiously anticipate Newman's early renditions of columns of light.[13] Further afield, Frederick Sommer's formulation of a horizon-less visual fabric in the late 1940s [pl. 56] paralleled the all-over impetus, often in tandem with a striking wealth of detail — witness Seliger's infinitesimal filigrees and the earlier Reinhardt's intricate textures [pls. 47, 41] — that motivated Abstract Expressionist practice.[14] The ideological link between these otherwise distinct artists was an interest, typical of the Second World War period and its aftermath when large realities were splintered, in the relationship between micro- and macrocosm, a longed-for unity amid multiplicity bonding nature and the human.[15]

Coincidence or superficial resemblance hardly explains the affinities between Abstract Expressionism and such photographers as Harry Callahan and Minor White. On the contrary, Callahan and White's pictorial meditations on landscape, light and geometry share similar tensions involving reductive abstraction and poetic evocation — alongside the imagery of the field — that engaged Newman, Rothko and Still. Notwithstanding the gulf in origins, means and meaning between such a composition as Newman's passionate *End of Silence* [pl. 33] and Callahan's cool *Weed Against Sky* (1948/58) [fig. 01], both deploy presence and pregnant void, hypnotic symmetry, organic vitality and rigorous economy.[16]

Like Newman, Callahan synthesized a romantic spirit (imparted from Alfred Stieglitz via Ansel Adams) with a classicizing formal preciseness (stemming from László Moholy-Nagy).[17] In turn, remember that White taught in the late 1940s, as did Still and Rothko, at the California School of Fine Arts. Certain later photographs by White have the primal, geological-looking cast and brooding chiaroscuro that mark Still's canvases. Others had earlier magicked the sea swell into a luminous upsurge against darkness [pl. 62], somewhat reminiscent again of Newman's elemental dramaturgy, together with the Whitmanesque theme of liquid flow beloved by Pollock.[18] In any event, the California School of Fine Arts was home to 'The San Francisco School of Abstract Expressionism'.[19] A narrow fly-papering of Abstract Expressionism to geography, restricting it to New York City, overlooks the West Coast counterparts. There, Sam Francis and Mark Tobey were of course foremost. Not only did Still and Rothko impress the young Francis, his orchestration of acutest chromaticism, scale, emptiness and painterly élan [pls. 8—10] amply justifies inclusion within an ecumenical purview of Abstract Expressionism. The same applies to Tobey in the Pacific Northwest. Tobey's handling of radiance, calligraphy and time as unifying ideas especially ties him on an expressive plane (though emphatically not on a social/personal one)[20] to the Abstract Expressionist ethos.[21] And if 'Abstract Expressionism' was anything, it was always less a clearly definable nucleus than a mingling of mentalities that overlapped around a moving center.

Above all, the choice of works aims for freshness and variety. Thanks to the aforementioned retrospectives in New York (and nearby Philadelphia and Washington), the public has had the opportunity during the past decade or so to relish renowned masterpieces by Newman, Pollock, Rothko *et alii*. Consequently, here are two of Rothko's conclusive late works on paper [pls. 44—45] probing scale versus color, alongside one of his less grandiose, more reticent 'dark pictures', the artist's own phrase for the canvases from 1957 onwards that he increasingly favored above the previous effusively colorful ones. Retreating upon itself in grayed silence, Rothko's *Untitled* (1960) [pl. 43] is a sure stepping-stone on the tenebrous path that would lead to his ultimate world elsewhere, the Houston Chapel. A hitherto almost unknown Newman from his *annus mirabilis* of 1949 [pl. 34] is dense with the inky blueness that expanded into the epic panorama of *Cathedra* (1951).[22] Turning to a different medium, a dramatic brush and ink on paper from the same breakthrough year as *Onement I* (1948) attests to the importance that this painter accorded to his draftsmanship: 'I know that if I have made a contribution, it is primarily in my drawing.'[23]

Moreover, dedicated spectators need only go a short distance from Rockefeller Center to peruse at leisure in MoMA or the Met such huge hallmarks of the movement as Pollock's *One: Number 31, 1950* and *Autumn*

Fig 01. Harry Callahan
Weed Against Sky, 1948/58
Gelatin silver print
7 × 7 in (18 × 18 cm)

Rhythm (both 1950). By comparison, this show undercuts the stereotype of Pollock's gigantism with five much smaller items.[24] These run from *Constellation* [pl. 35], revealing Pollock's under-estimated vivacity as a colorist, via two quintessential pourings of great urgency [pls. 37—38], to another from the end of his 'classic' phase of 1947—1950 in which flux approaches dissolution [pl. 36],[25] thence to the compositions done on stacked, porous Japanese papers so that inks from the upper sheet bled into that below and were then embellished. In *Untitled* (1951) [pl. 39] we face a mirror image of already occulted marks that adumbrate semaphores of consciousness scattering towards disappearance.[26] In a reversal of customary roles, Krasner's cataclysmic *Another Storm* [pl. 21] proclaims her esthetic largeness against Pollock's smallness, which only blossomed to the full once she had relegated him to memory.[27]

Still, *Abstract Expressionism — A World Elsewhere* does not eschew big iconic statements. By any reckoning, Francis's *Blue-Black* (1952) [pl. 09], Still's *Untitled (PH-847)* (1953) [pl. 57], Kline's *Vawdavitch* (1955) [pl. 19], Smith's *Voltri-Bolton X* (1962) [pl. 53], Motherwell's *Elegy to the Spanish Republic* (1970) [pl. 29], Pousette-Dart's *Time is the Mind of Space, Space is the Body of Time* (1979—82) [pl. 40] and de Kooning's consummating *Triptych* (1985) [pl. 04], among others, are tours-de-force. However, the extremes that Abstract Expressionism spanned require more than eye-opening performances alone to serve them well. This is why the spectrum stretches from a carnivalesque *Hostess* (1973) [pl. 07], who, higgledy-piggledy, ushers us in, to Still's chthonic underworld in *1955-M-No.2 (PH-776)* (1955) [pl. 56] or Gottlieb's supernal *Levitation* (1959) [pl. 15] — and from the aquatic reaches of Baziotes's *Mariner* (1960—61) [pl. 01] to the ominous, figurative drollery of Guston's *Downtown* (1969) [pl. 17]. Whether the heavens or the ocean deep, the Yeatsian 'foul rag-and-bone shop' of whatever lurks beneath Guston's 'hoods' beckoning beyond their confines,[28] the shadowy stains within Motherwell's *Figure with Blots* (1943) [pl. 26], or the empty space into which Smith's silhouettes dilate, the flip side to the material here-and-nowness of Abstract Expressionism was its manifold fixation upon worlds elsewhere.

From a quotidian standpoint, most of the Abstract Expressionists had good reasons to shun their immediate surroundings. The youthful self-portraits by Pollock, Rothko, de Kooning [fig. 04], Gorky and Kline bespeak their mutual malaise. Respectively, from the early 1930s onwards these artists portrayed themselves as: a fearful head surrounded by darkness; someone with their glasses' lenses oddly blacked out; a stiff man standing forlorn and looking heavenwards with anxious eyes; a sad child imagined at the age of nine; and as a tragic clown.[29] It is the plight already set in the poet A.E. Housman's lines:

> I, a stranger, and afraid
> In a world I never made.[30]

Pollock summarized this alienation, speaking by proxy and proleptically for his colleagues-to-be when he wrote in 1929, 'People have always frightened and bored me consequently I have been within my own shell.'[31] This is Romantic Idealism's predicament *par excellence*, consciousness imprisoned within its shell.[32] Gottlieb's *Wasteland* [fig. 03] evokes the dun desolation from which his generation sought escape. Actually or metaphorically, most of the artists were strangers in a strange land. Rothko's childhood experience (real or fantasized) of anti-Semitism and his transplantation from Russia (his birthplace) to a land where 'he never felt entirely at home'[33]; Guston's trauma of his father's suicide, his brother's death by gangrene and scary encounters with the insurgent Ku Klux Klan in 1930s Los Angeles; Gorky's loss of his cherished Armenian homeland; Smith's fraught confrontation with the Fascist foe (graphically etched in his *Medals for Dishonor*); and Still's struggle with the disasters of drought and the Great Depression on the Canadian prairies — these and further rebarbative realities were cause enough to propel the Abstract Expressionists towards a world elsewhere.

Rothko's *Thru the Window* [fig. 02] neatly encapsulates this flight of consciousness. In a reprise of the Renaissance architect Leon Battisa Alberti's famous model of painting as a window, Rothko positions himself beside a latter-day window and inside a transparent perspectival frame, the woman and the red painting on the easel acting like projections of his imagination.[34] Rothko's wider lifelong obsession with architecture — the doorways, windows and facades that Romanticism had already exploited for symbolic ends[35] — signified the constructs through which the self might pass into spaces of otherness. As Rothko wrote in 1947, when his art was on the cusp of this leap, 'Ideas and plans that existed in the mind at the start were simply the door through which one left the world in which they occur.'[36] Rothko characterized his mature images as 'facades', adding that 'sometimes I open one door and one window or two doors and two windows'.[37] As facades can at once hide and reveal what lies beyond, so windows may be open or shut.[38] Rothko's architectural metaphors for his tiered rectangles, the lone inhabitants of his paintings after 1950, not only points to their capacity to both beckon and baffle the gaze, but also to a recurrent theme in American culture, particularly its literature. In a nutshell, it is the metaphor of building a housing or structure for individual consciousness. Here, Richard Poirier's cogent enquiry into the spaces of American thought and fiction, *A World Elsewhere — The Place of Style in American Literature* (1966), presents some invaluable insights into those of Abstract Expressionism.

Poirier's central thesis is that:

> American books are often written as if historical forces cannot possibly provide such an environment, as if history can give no life to 'freedom', and as if only language can create the liberated place. The classic American writers try through style temporarily to free the hero (and the reader) from systems, to free them from the pressures of time, biology, economics, and from the social forces which are ultimately the undoing of American heroes and quite often of their creators… They tend to substitute themselves for the world.[39]

We have only to compare this theory with one of Abstract Expressionism's grounding declarations of rights, Newman's essay 'The Sublime is Now' (1948), to grasp the link:

> I believe that here in America, some of us, free from the weight of European culture, are finding the answer… We are freeing ourselves of the impediments of memory, association, nostalgia, legend, myth, or what have you that have been the devices of Western European painting. Instead of making *cathedrals* out of Christ, man or 'life', we are making [them] out of ourselves.[40]

In other statements, Newman reiterated that his art opposed the environment, instead establishing an existential one of its own, as for example when he described his epiphany at the Indian mounds of Ohio: 'Looking at the site you feel, Here I am, *here*… and out beyond there is chaos.'[41] The stanchion black and white verticals in *Untitled* organize the potential 'chaos' of the fathomless blue-black in an analogous manner, as does the vivid 'zip' amid the murky atmosphere of *Moment* [pl. 32], finessing their designs from purposeless sensations of mere spatial play into a focused one specifically orientated to the onlooker's acuity and uprightness. A concord is thereby established between our sentience and the contemplative images. While that lasts, Newman's art hinges on the experience of time. If Newman's express purpose — with his radical reduction of formal means and concomitant amplification of visual impact — was to heighten the viewer's apperception, then its crux foregrounds duration or temporality.[42] Being is inseparable from the consciousness of time; we live time.[43] Scant wonder that Newman observed of his painting that 'the beginning and the end are there at once' and that the title of *End of Silence* highlights a moment.[44]

From Newman's myth of America as a *tabula rasa* for new beginnings in which the individual would regenerate himself,[45] it is a short step to extrapolate the polarized dynamics that govern Poirier's 'world

elsewhere' — the relationship between self and environment. These are also the twin, omnipresent poles of Abstract Expressionism. Their guises are as mutable in Abstract Expressionist art and discourse as their continuity is fixed. Once this duality is understood, many loose ends fall into place. Pollock's retort to Hofmann's criticism that he did not paint from nature — 'I *am* nature' — was the perfect, if unintended counterweight to Still's later pronouncement, 'I paint only myself, not nature.'[46] Like the texts and heroes of Poirier's American literature, for the Abstract Expressionists external nature and inward consciousness were reversible.[47]

Lest these binary oppositions sound naïve or invite deconstruction into the aporetic minutiae of *différance*, the fact remains that the Abstract Expressionists were dialectical to their core.[48] How could any group schooled in the thinking of Karl Marx, Sigmund Freud and Carl Jung be otherwise? One of their mentors, the eccentric John Graham, spoke for them all in his influential tract *Systems and Dialectics of Art* (1937) when he wrote: 'The universe consists of two commensurable elements — Space and consciousness.'[49]

The evolution of Still and Pollock's art demonstrates Poirier's theme particularly well. In 1934 Still depicted an Adamic naked figure striding over a dark wilderness [fig. 05]. He walks in a culturally loaded direction — from right to left — against the grain, that is, of normative perceptual habits. We might say that the man exits the image for a world elsewhere. Far-fetched? Hardly, insofar as Still later provided a subtext:

> It was as a journey that one must make, walking straight and alone. No respite or short-cuts were permitted… until one had crossed the darkened and wasted valleys and come at last into clear air and could stand on a high and limitless plain. Imagination, no longer fettered by the laws of fear, became as one with Vision.[50]

Apart from echoing Gnostic language, Still's words evoked his nineteenth-century forebear Ralph Waldo Emerson, whose Transcendentalism urged the artist both to take possession of America in the eye (thus, perhaps, Still's recurrent emphasis on 'vision') and to 'build therefore your own world'.[51] Subsequently, the gist of Still's long pictorial odyssey entailed the archetypal vertical protagonist and its fusion with the ambience. In the furiously trowelled, penumbral brown continuum of *1955-M-No.2 (PH-776)*, neither figure nor ground prevails: everything merges into a wall of violent yet petrified activity — the pictorial architecture, as it were, of intensified consciousness. In *Untitled (PH-847)* the rarified modulation from subfusc to dazzlingly light hues, and from thick impasto to a razor-thin matière (accentuated by the ultra-slender 'life-line' racing through the full height leftward of center), further conveys the dialectical switch from heavy burden to uplifted expansion. 'By then,' as Still once remarked of his leaving representation behind, 'it's something else, of course, a whole new world.'[52]

In both Stills the marginal motifs either cut by the edge or set near it — among his most conspicuous stylistic traits — match a common tendency in Abstract Expressionism. Its manifestations include Newman's peripheral 'zips', the edgings or outermost areas around Rothko's rectangles, Pollock's recourse to 'no limits, just edges',[53] the impression that Smith's sculptures and Francis's later arrangements often give of being invaded by (or invading) emptiness, the ferocity with which the vectors in Kline's *Vawdavitch* and Mitchell's *Untitled* [pl. 23] hurtle against the canvases' bounds and the gaudy background barely sighted behind the ashen biomorphs in de Kooning's *Abstraction* [pl. 05], which themselves look to be slipping out of the frame. Apart from the routine connotations of unbounded space, the effects conform to a larger pattern: cues to a liminal world elsewhere lurking beyond the visible.[54] Although past art had broached these remote or arcane regions — from the minuscule figures in the background of early Netherlandish painting, via the almost invisible ship that rescues Théodore Géricault's *Raft of the Medusa* (1819), to Edgar Degas' cropped *japonisme* — Abstract Expressionism raised them to a metaphysical pitch.[55]

Clockwise:
Fig 02. Mark Rothko
Thru the Window, 1938/39
Oil on gesso board
10 × 7 in (25 × 17.5 cm)

Fig 03. Adolph Gottlieb
Wasteland, 1930
Oil on canvas
22 × 34 in (56 × 86.5 cm)

Fig 04. Willem de Kooning
Self-Portrait in the Wilderness, 1947
Oil and charcoal on board
20 × 22 in (51 × 56 cm)

Fig 05. Clyfford Still
Untitled (PH-323), 1934
Oil on canvas
59 × 33 in (150 × 84 cm)

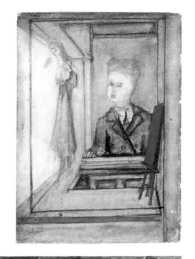

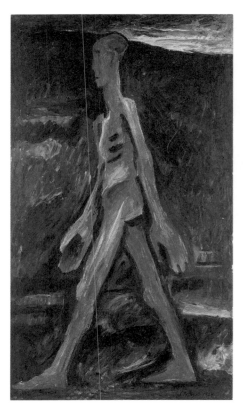

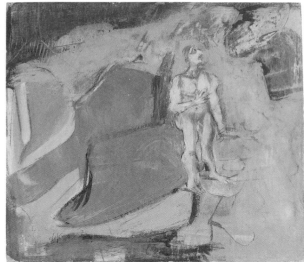

A WORLD ELSEWHERE

To resume Poirier's scheme, Pollock's entire artistic quest might be couched in 'the American obsession with inventing environments that permit unhampered freedom of consciousness'.[56] Certainly, like Poirier's chosen writers — Henry David Thoreau, Emerson, Herman Melville, Scott Fitzgerald — Pollock was 'bathed in the myths of American history that carry the metaphoric burden of a great dream of freedom — of the expansion of national consciousness into the vast spaces of a continent and the absorption of those spaces into ourselves'.[57] Listen to Pollock's clichéd claim, 'The West is in it some way — roll of the plains, maybe, a wind in the grasses.'[58] *Going West* (c.1934—1935) again posits, like Still's *Untitled* (1934), its characters' sinister passage from right to left and their assumption into the whirling land- and sky-scape. Thereafter, Pollock's principal direction was to escape the nightmarish 'Gothic' incarceration of his body/'shell' for some transcendent, imponderable spaciousness.

The key juncture came when the pressures compacting Pollock's tortured anatomies and symbols became so strong that the visual congeries began to shatter, torn between centripetal and centrifugal forces. The diminutive *Constellation* is among the 'Accabonac Creek' series (1946) wherein, as the title may hint, the celestial starts to supplant the terrestrial travails of the body. Whatever substance the bestial remnants possess, it is dispersing into the driven pigment, the sharp tints reminiscent of some acid solvent. Intriguingly, one of Pollock's first 'pourings', *Galaxy* (1947), was painted over an earlier scene, *The Little King*, done around the same time as *Constellation*, as though materially to veil its figuration with a preternatural palimpsest.[59] *Number 17, 1950 (Fireworks)* typifies, in miniature, the re-enchantment of the erstwhile clogged world of the body. Now everything is a sparkling, outlaid cosmic dance (note here, and throughout the dripped idiom, the shimmering metallic paint).[60]

Free from urban constraints and stirred by the ambient waters, countryside and sky of eastern Long Island, Pollock had discovered the liberated space for his consciousness, with a tacit nod towards Emerson's admonishment, 'But if a man would be alone, let him look at the stars.'[61] An illuminating clarification of Pollock's transition from intolerable culture into reparative nature occurs in Charles Laughton's film *The Night of the Hunter* (1955). The two beleaguered children of Laughton's drama escape their murderous pursuer by floating downstream in a boat on a night voyage. Abruptly their 'Gothic' tribulations segue to a twinkling cosmos of glistening water and stars [fig. 06].[62] This is exactly Pollock's emotional *volte-face* in 1947. It would explain, too, such a puzzling confession as 'I saw a landscape the likes of which no human being could have seen.'[63] To which Lee Krasner added, 'In Jackson's case I feel that what the world calls "visionary" and "real" were not as separated as they are for most people.'[64] It is New England Transcendentalism redivivus.[65]

Pollock's mature pourings, begun a year after *Constellation*, map his spatial ambit. In *Number 1A, 1948* [fig. 07] the handprints stamped across the upper zone signify the artist's vestigial span, with the painting's 'body' between and below these markers atomized into the hallmark airy labyrinths. Although *Number 19, 1949* is tiny compared with his big canvases, its scale feels comparable insofar as it dictates a reign of wonder at the fleetness of its myriad convolutions. Whether we wish to succumb to its spell with an innocent eye or historicize it (as some art historians prefer) or both, does not impinge on Pollock's relation to an American tradition of eccentric, rapt and consciously naïve visuality.[66] The inward panoplies of Seliger's *Multicellular Apparition*, Tobey's *Yellow Harbor* and Pousette-Dart's *Time is the Mind of Space, Space is the Body of Time* — packed, translucent, hallucinatory — elicit the same mode of looking. They affect to turn our eyesight into a panopticon. Such artists can only 'exist' in this abstract matrix insofar as, to paraphrase Poirier, there is no place in the real world for their oceanic feelings and visionary attitude, 'no place at all except where a writer's style can give them one'.[67] For 'writer', read 'painter/sculptor'. What about, as Poirier's sub-title urged, the place of 'style'?

The mistake is to equate 'style' in Abstract Expressionism with Greenbergian formalism or Byzantine art for art's sake, a self-enclosed referentiality lacking personal, existential, cultural or historical resonance.

Fig 06. Still from *The Night of the Hunter* (1955)

Fig 07. Jackson Pollock
Number 1A, 1948, 1948
Oil and enamel on unprimed canvas
68 × 104 in (172.5 × 264 cm)

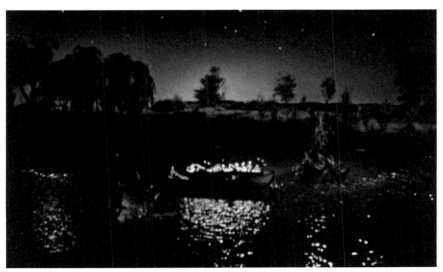

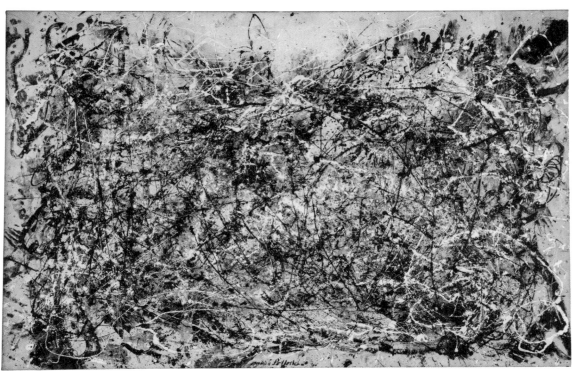

By contrast, the Abstract Expressionists' 'signature' styles are the manifest tokens of their having built a world elsewhere amid the highly prosaic circumstances of their walk-up studios (vividly recorded throughout this catalog in Fred W. McDarrah's photographs).[68]

For example, Smith literally constructed a sculptural progeny of things and personages to people his lonely environment at Bolton Landing. Lewis's rainbow tesserae nestled amid blackness articulate some alternative night world abuzz with jazz rhythms [pl. 22].[69] Hofmann's zinging *Pagliaccio* [pl. 18] adverts to the time-honored equivalence for emotional states in music's autonomy.[70] In the landmark *Red Painting*, Reinhardt began to dissolve stable geometry into numinous monochromaticism that floods our perception [pl. 42]. Subdued to grisaille, this color-field organization meets a metronome-like beat in the minutely parsed rivulets of Tworkov's *Idling II* [pl. 61].[71] Francis's congealed oil washes of the early 1950s intimate a visceral, corpuscular interiority to which his ensuing rhapsody with whiteness objected an empyrean vacancy. Pollock himself deemed painting 'a state of being' and, famously, 'energy and motion made visible/memories arrested in space'.[72] In *Untitled* (c.1951), natural flotsam — pebbles — conflate themselves with the wayward drift of the artist's gestural pulse and bloody red and sickly yellow pigment in a provocative mix of the formless with the flesh, bringing to mind Walt Whitman:

> I effuse my flesh in eddies, and drift it in lacy jags.
> I bequeath myself to the dirt to grow from the grass I love,
> If you want me again look for me under your boot-soles.[73]

The blue and vernal green in de Kooning's *Untitled* (1961) [pl. 03] bring the glimpsed landscape's tones into the pink that he equated with flesh.[74] His *Triptych* revisits the tumult of his late 1940s idiom in order to pacify it to an uncanny, beautiful quietus. Sometimes, loss of a concrete touchstone engendered in the artists an alternative dimension. This is why the prevalent register of Gorky's paintings and drawings is pastoral — a vehicle inseparable from illusion, nostalgia and psychological introspection, in Gorky's case relating to a half-remembered Armenia superimposed on Virginia's countryside.[75] Motherwell's *Elegy to the Spanish Republic* at once mourns a historical loss — 'a terrible death... that should not be forgot'[76] — and conjures shapes that double as grave likenesses, akin to those in Ezra Pound's *haiku*:

> The apparition of these faces in the crowd;
> Petals on a wet, black bough.[77]

In Motherwell's collages, fragments are synecdoches for a wider awareness: a nod to the magazine *Art International* invokes the cosmopolitan art world, a Gauloises label that of breezy European bohemia beside a paint-cum-sea splash. *A fortiori*, each artist's style itself is the synecdoche, the part that embodies some larger and ultimately ineffable whole.[78]

Against their early dejection and worse ills the artists reconfigured themselves through style, again rather as Whitman melded the private and transcendent into his 'Song of Myself' (1855). As I have written of Kline, 'The power of abstraction catalyzes an intense faith in the medium. A new grasp of the medium then transforms an erstwhile downbeat message' and the self is reborn as style.[79] The result is that — be it Kline's spectacularly wrecked armatures, de Kooning's sweeping strokes, Gorky's knotting and unraveling of pastness, Gottlieb's enigmatic grids or subsequent polarities, Baziotes's limpid phosphorescence and Pollock's strenuous skeins — we are made as conscious of the voice as of any message it has to impart.

If, as the critic Leo Bersani tellingly suggested, '*A World Elsewhere* is the history of an illusion about the power of individual style radically to transform history and language, it also treats that illusion as demonstration

of "the heartbreaking *waste* of heightened human consciousness, the waste of art on the final relentless ordinariness of daily life".[80] The simultaneous power and pathos of Abstract Expressionism lies in the gap between its grand, liberating or sublime aspirations and the banality or vicissitudes of the times of their creation — Cold War paranoia, the cheap anodynes of the drive-in movie theater and television, the insidious reign of kitsch and corporate capitalism, pernicious racism, the 'lonely crowd' syndrome in the conformist Eisenhower era and all those other deleterious phenomena which ensured their America was what Henry Miller presciently called 'the air-conditioned nightmare' (1945). Yet, perhaps in Poirier's words, 'to take possession of America, in the eye, as an Artist, is a way of preserving imaginatively those dreams about the continent that were systematically betrayed by the possession of it for economic and political aggrandizement'.[81] At the least, Abstract Expressionism was an indelible artistic episode in the history of a wish for a world elsewhere probably as old as human longing itself. More eloquently than most, the seventeenth-century poet Andrew Marvell had captured it for posterity in his paen to the imagination, voicing a sentiment still relevant today:

> Mean while the Mind, from pleasure less,
> Withdraws into its happiness:
> The Mind, that Ocean where each kind
> Does streight its own resemblance find;
> Yet it creates, transcending these,
> Far other Worlds, and other Seas.[82]

1 As I write, a nearby chain hotel in King's Cross, London, has production-line art versions of Rothko's paintings adorning its restaurant.

2 Still and de Kooning remain the two principal exceptions, though a catalogue raisonné of Rothko's abundant works on paper is also long awaited.

3 Epitomized, respectively, by Serge Guilbaut, *How New York Stole the Idea of Modern Art: Abstract Expressionism, Freedom and the Cold War* (Chicago and London: 1983) and Stephen Polcari, *Abstract Expressionism and the Modern Experience* (Cambridge and New York: 1991).

4 Norman Kleeblatt, ed., *Action/Abstraction: Pollock, de Kooning, and American Art, 1940—1976* (The Jewish Museum, New York: 2008).

5 For example, Thomas Crow, *The Rise of the Sixties: American and European Art in the Era of Dissent, 1955—69* (London: 1996), which regards Abstract Expressionism as a relative dead-end compared with Pop Art and its affinities.

6 Maurice Berger, 'Timeline,' in Kleeblatt, op. cit., p. 19; George Dondero, 'Communists Maneuver to Control Art in the UnitedStates' (1949), in Charles Harrison and Paul Wood, eds., *Art in Theory: 1900—1990* (Oxford: 1992), pp. 654—58.

7 See Ann Eden Gibson, *Abstract Expressionism: Other Politics* (New Haven: 1997).

8 Notwithstanding Helen Frankenthaler's seminal contact with Abstract Expressionism, she strikes me as belonging more to subsequent developments.

9 Also, to encompass the bulk of second-generation Abstract Expressionism would have spelt a completely different exhibition. The inclusion of Joan Mitchell — her art deeply attached to de Kooning, Kline and Gorky — is the exception.

10 The same obtains for the Jewish Museum's *Action/Abstraction*, which covers second-generation Abstract Expressionism, Color-Field, Pop, Happenings and so forth.

11 The sole general survey of the movement in comparatively recent times was *Abstract Expressionism: The Critical Developments* at the Albright-Knox Art Gallery in 1987; it drew heavily on the museum's superlative collection, excluded sculpture and did not travel.

12 Another crucial figure here was the Albanian-born Gjon Mili, whose photographs often featured in *Life* magazine.

13 Between 1942 and 1948 MoMA included Morgan's photographs in no fewer than six exhibitions.

14 Sommer associated with the gallerists Howard Putzel (whom he met as early as 1936) and Charles Egan, both of whom were key figures in the development of Abstract Expressionism. The Museum of Modern Art's traveling exhibition *New Photographers* (1946) also included Sommer, significantly alongside Callahan and Siskind. See *The Art of Frederick Sommer: Photography, Drawing, Collage* (Prescott, New Haven and London: 2005).

15 Hence the period appeal of Far Eastern art and philosophy to artists otherwise as separate as Tobey and Reinhardt.

16 Again like certain Abstract Expressionists — including Pollock and Lewis — jazz was an important stimulus for Callahan.

17 See Britt Salvesen and John Szarkowski, *Harry Callahan: The Photographer at Work* (The Center for Creative Photography, Tucson: 2006), p. 14. I can think of no better term to encapsulate Newman's entire aesthetic than romantic classicism.

18 White joined the staff of the California School of Fine Arts in 1946, the same year as Still. Previously, White had studied at Columbia under Meyer Schapiro, an important mentor to several Abstract Expressionists.

19 Susan Landauer, *The San Francisco School of Abstract Expressionism* (Berkeley and London: 1996).

20 For a start, Tobey's homosexuality and quietism set him far apart from the masculinist extroversion of much New York Abstract Expressionism.

21 On Tobey's neglect and his influence on Pollock, see Judith S. Kays, 'Mark Tobey and Jackson Pollock: Setting the Record Straight,' in *Mark Tobey* (Museo Nacional Centro de Arte Reina Sofia, Madrid: 1997).

22 On the importance of the year 1949, see Yve-Alain Bois, 'On Two Paintings by Barnett Newman,' *October* 108 (Spring 2004).

23 '"Frontiers of Space": Interview with Dorothy Gees Seckler' [1962], in John P. O'Neill, ed., *Barnett Newman: Selected Writings and Interviews* (New York: 1990), p. 251. 'Drawing', broadly understood as ordonnance, was the conduit that allowed Newman to reconfigure color, light, measure and, thus, time.

24 Regarding Pollock's monumentality — the large scale of his small works — see Francis V. O'Connor, *Jackson Pollock: Small Poured Works, 1943—1950* (Pollock-Krasner House and Study Center, East Hampton: 2006).

25 Pollock gifted this painting to Hans Namuth soon after the latter made his second film of the artist at work. Therefore it probably dates from either very late 1950 or early the next year.

26 For the uppermost companion sheet, see, *No Limits, Just Edges: Jackson Pollock Paintings on Paper* (Solomon R. Guggenheim Museum, New York: 2005), p. 114.

27 On the problematics of Krasner as Pollock's 'other', see Anne M. Wagner, 'Lee Krasner as L.K.,' *Representations* 25 (Winter 1989).

28 Christopher Bucklow, *What is in the Dwat: The Universe of Guston's Final Decade* (Grasmere: 2007) is a fascinating interpretation of Guston's imagery as having arisen from a world elsewhere, a 'Lower Level'.

29 For the Rothko, Gorky and Kline self-portraits, see David Anfam, *Abstract Expressionism* (New York and London: 1990), pp. 19—20; for a second by de Kooning, see *American Self-Portraits* (National Portrait Gallery, Washington DC: 1974), pp. 182—83.

30 A.E. Housman, 'A Shropshire Lad' (c.1900, publ. 1922).

31 Letter to Charles and Frank Pollock (22 October, 1929), in Helen A. Harrison, ed., *Such Desperate Joy: Imagining Jackson Pollock* (New York: 2000), p. 8.

32 For an authoritative analysis of this subject, see Frank Kermode, 'Solitary Confinement,' in *The Sense of an Ending: Studies in the Theory of Fiction* (London and New York: 1966), pp. 153—80.

33 John Fischer, 'The Easy Chair: Mark Rothko, Portrait of the Artist as an Angry Man, 1970,' in Miguel López-Remiro, ed., *Mark Rothko: Writings on Art* (New Haven and London: 2006), p. 132.

34 Rothko could readily have been alerted to Alberti's conception by Giorgio Vasari's *Lives of the Artists* (1555), a text he certainly knew. Indeed, compare the fantasies of scale in *Thru the Window* and Vasari's words: 'Alberti similarly discovered a way of tracing natural perspectives and effecting the diminution of figures, as well as a method of reproducing small objects on a large scale'; Vasari, *Lives of the Artists*, transl. George Bull, vol. 1 (London: 1965), p. 210.

35 The classic study is Lorenz Eitner, 'The Open Window and the Storm-tossed Boat,' *The Art Bulletin* 37 (1955), pp. 281—90. The title of the Belgian Symbolist Fernand Khnopff's *I Close the Door upon Myself* (1891) typifies the flavor of the long after-life of such Romantic *topoi*. On framing in Rothko's art, see my essay, 'The World in a Frame,' for the catalog of Tate Modern's *Rothko: The Late Series* exhibition, forthcoming this September.

36 'The Romantics were Prompted, 1947,' in López-Remiro, op. cit., p. 58.

37 'Address to Pratt Institute, November [sic] 1958,' in ibid., p. 126.

38 Cf. Ann Friedberg, *The Virtual Window* (Cambridge and London: 2006), p.32: 'Alberti supplies us with a Renaissance root for the concept of a windowed "elsewhere" — not a realism of subject matter but a separate spatial and temporal view.'

39 Richard Poirier, *A World Elsewhere: The Place of Style in American Literature* (Madison and London: 1966, 1985), p. 5.

40 'The Sublime is Now' (1948), in O'Neill, op. cit. p. 173.

41 'Ohio, 1949,' in ibid., p. 174.

42 Similarly, the title of Smith's *Seven Hours* (see pl.55) references the time it took to make the sculpture.

43 This explains the similarities between Newman's ideas and Martin Heidegger's philosophy.

44 'Interview with Emile de Antonio' (1970), in O'Neill, op. cit., p. 306. Newman's concept of the spatialized moment in which time past, present and future coalesce belongs to a considerable lineage of modernist epiphanies. In turn, these have venerable roots in St. Augustine's vision of the *aevum*, in which the temporal and the eternal coincide; see Kermode, op. cit., pp. 71—2, 173.

45 Of course such myths (apart from being pointedly gendered — recall the title of Newman's essay, 'The First Man was an Artist' and of *Vir Heroicus Sublimis*, 'Man, Heroic and Sublime') are, especially judged by present-day standards, both highly politically incorrect and fallacious because the continent had been inhabited for millennia before Europeans brought to it their own mass of culture. As Leo Bersani noted in his astute foreword to Poirier's book, 'America has always been culturally surfeited.'

46 Steven Naifeh and Gregory White Smith, *Jackson Pollock: An American Saga* (New York: 1989), p. 486; J. Benjamin Townsend, 'An Interview with Clyfford Still,' *Albright-Knox Art Gallery Notes* (Summer 1961), p. 11.

47 For the Romantic cultural background to this dualism, see M.H. Abrams, *The Mirror and the Lamp: Romantic Theory and the Critical Tradition* (New York: 1953, 1958). The peculiar distortions of

Rothko's figures in the 1930s — either straitened by the ambient space or swelling to fill it — are one of numerous early, telltale signs of the defining Abstract Expressionist intercourse between self and environment.

48 Gottlieb even wrote a list of dialectical oppositions in 1956, titling it 'Polarities'; *Adolph Gottlieb: 1956* (Hyde Collection, Glens Falls: 2005), p.13. My thanks to Sanford Hirsch for drawing my attention to this document in the Adolph and Esther Gottlieb Foundation archives.

49 John Graham, *John Graham's Systems and Dialectics of Art* (Baltimore and London: 1937, 1971), p. 179.

50 'Letter to Gordon Smith,' in *Paintings by Clyfford Still* (Albright Art Gallery, Buffalo: 1959), n.p.

51 Poirier, op. cit., pp. 3, 6, paraphrasing Emerson's essay 'Nature' (1836).

52 Thomas Albright, 'Seeking the Vastness and Depth of a Beethoven Sonata or a Sophocles Drama,' *ArtNews* 79 (September 1980), p. 160.

53 Harrison, op. cit., p. 93.

54 The attempt to materialize the invisible was among the catalysts of abstraction's first wave in the early twentieth century; see Mel Gooding, *Abstract Art* (Cambridge: 2001), pp. 12—31.

55 See Alfred Acres, 'Elsewhere in Early Netherlandish Painting,' in Bodo Brinkmann, Jeffrey Hamburger, and Anne Korteweg, eds., *Tributes in Honor of James Marrow: Studies in Painting and Manuscript Illumination of the Late Middle Ages and Northern Renaissance* (London and Turnhout: 2006), pp. 23—33.

56 Poirier, op. cit., p. 8.

57 Ibid., p. 3.

58 Jeffrey Potter, 'Jackson Pollock: Fragments of Conversations and Statements,' in Harrison, op. cit., p. 86.

59 Might some of *Constellation*'s schemata be a freewheeling fantasia associated with the signs of the zodiac? Note, for example, the ♋ motif at upper left reminiscent of the sign for Cancer. With regard to *Constellation*, tantalizingly Regulus means 'the little king' — the title of the painting underneath *Galaxy* — and is a star in the constellation Leo. However, reading too much into Pollock's titles is a pitfall to avoid.

60 On the celestial theme in Pollock, see Kirsten A. Hoving, 'Jackson Pollock's *Galaxy*: Outer Space and Artist's Space in Pollock's Cosmic Paintings,' *American Art* 16 (Spring 2002), pp. 82—93.

61 'Nature,' in Carl Bode, ed., *The Portable Emerson* (New York and London: 1981), p. 9.

62 Greenberg was the first to identify supposedly 'Gothic' qualities in Pollock's pre-1947 art and, in doing so, almost certainly took his cue (albeit unacknowledged) from F.O. Mathiessen's *American Renaissance: Art and Expression in the Age of Emerson and Whitman* (New York: 1941).

63 B.H. Friedman, 'An Interview with Lee Krasner Pollock' (1969), in Pepe Karmel, ed., *Jackson Pollock: Interviews, Articles, and Reviews* (New York: 1999), p. 37.

64 Ibid.

65 For a broad narrative of the Transcendentalist strain in American art, see Barbara Novak, *American Painting of the Nineteenth Century: Realism, Idealism and the American Experience* (New York: 1969, 1979) and ibid., *Voyages of the Self: Pairs, Parallels, and Patterns in American Art and Literature* (Oxford and New York: 2007). What methodology must beware is the supposition of some trans-historical 'American mind' in operation, rather than attitudes that have a firm grounding in historical and social contexts.

66 See Tony Tanner, *The Reign of Wonder: Naivety and Reality in American Literature* (Cambridge: 1965).

67 Poirier, op. cit., p. xxi. In answer to the charge of escapism, Poirier (p. 5) again yields a thought: 'They resist within their pages the forces of environment that otherwise dominate the world.'

68 Smith's *Home of the Welder* (1945) was a precocious stab at this target, his later *Hudson River Landscape* its apotheosis. Newman's characterization of his paintings as 'space-domes' also belongs to Poirier's concept of 'building' environments.

69 *Norman Lewis: Black Paintings, 1946—1977* (Studio Museum in Harlem, New York: 1998).

70 A Romantic shibboleth that nevertheless has an extensive modernist currency. Especially relevant to the Abstract Expressionist alternation between abject reality and a 'sublime' or revivifying self-made one is how in Jean-Paul Sartre's *Nausea* (1938) music periodically punctuates, like an epiphany, the horror of existence.

71 Richard Armstrong, 'Jack Tworkov's Faith in Painting,' in *Jack Tworkov: Paintings, 1928—1982* (Pennsylvania Academy of the Fine Arts, Philadelphia: 1987), p. 28.

72 Selden Rodman, 'Jackson Pollock' (1957), in Harrison, op. cit., p. 53; handwritten statement (1950), in Karmel, op. cit., p. 24.

73 'Song of Myself' (1855), l. 1338—40, in Francis Murphy, ed., *Walt Whitman: The Complete Poems* (London: 1975), p. 124.

74 Cf. de Kooning: 'flesh was the reason why oil-painting was invented!'; 'Conversation with Bert Schierbeck' (1969), in *The Collected Writings of Willem de Kooning* (Madras and New York: 1988), p. 167.

75 Laurence Lerner, *The Uses of Nostalgia: Studies in Pastoral Poetry* (New York: 1972), p. 19.

76 Margaret Paul, 'Robert Motherwell: A Conversation at Lunch,' in *Robert Motherwell* (Smith College, Northampton: 1963), n.p.

77 'In a Station of the Metro' (1913). Robert Hobbs has also enriched the open-ended associativeness of Motherwell's leitmotifs in the *Elegies* with the stimulating proposal that they allude to Virgil's notion of death as life's bitter, tragic fruit. Further ties to nineteenth-century Transcendentalism may be implicit in the title of *The Tomb of Captain Ahab* (1953), which in format is actually an *Elegy*.

78 Ibid., p. 84.

79 *Franz Kline: Black & White, 1950—61* (Menil Collection, Houston: 1994), p. 15.

80 Bersani, xvii-xvii, in Poirier, op. cit., quoting p. 137.

81 Ibid., p. 51. This politico-ethical undertow explains how Newman, for example, could claim that his painting, if read properly, 'would mean the end of all state capitalism and totalitarianism'; Seckler, in O'Neill, op. cit., p. 251.

82 'The Garden' (publ. 1681). From Marvell's metaphor of the Mind as an ocean holding doubles of reality, it is possible to chart an intellectual pedigree back to Neo-Platonism and forward to the Symbolist doctrine of 'correspondences' expounded by Charles Baudelaire, in turn a prime inspiration for Motherwell. Many aspects of Abstract Expressionism — including the faith in the image as ineffable or revelatory, the distrust of language, the doctrine of the two worlds and the linkage between the material and the metaphorical — hark back (not altogether coincidentally, since both Still and Motherwell, if not other Abstract Expressionists, were versed in Plato) to Neo-Platonic tenets: see E.H. Gombrich, 'Iconaes Symbolicae,' in *Gombrich on the Renaissance* vol. 2: *Symbolic Images* (London: 1972), pp. 123—95.

PLATES

WILLIAM BAZIOTES
HARRY CALLAHAN
WILLEM DE KOONING
SAM FRANCIS
ARSHILE GORKY
ADOLPH GOTTLIEB
PHILIP GUSTON
HANS HOFMANN
FRANZ KLINE
LEE KRASNER
NORMAN LEWIS
JOAN MITCHELL
BARBARA MORGAN
ROBERT MOTHERWELL
HANS NAMUTH
BARNETT NEWMAN
JACKSON POLLOCK
RICHARD POUSETTE-DART
AD REINHARDT
MARK ROTHKO
CHARLES SELIGER
AARON SISKIND
DAVID SMITH
FREDERICK SOMMER
CLYFFORD STILL
MARK TOBEY
JACK TWORKOV
MINOR WHITE

WILLIAM BAZIOTES

01. *Mariner*, 1960—61
Oil on canvas
66 × 78 in (167.5 × 198 cm)

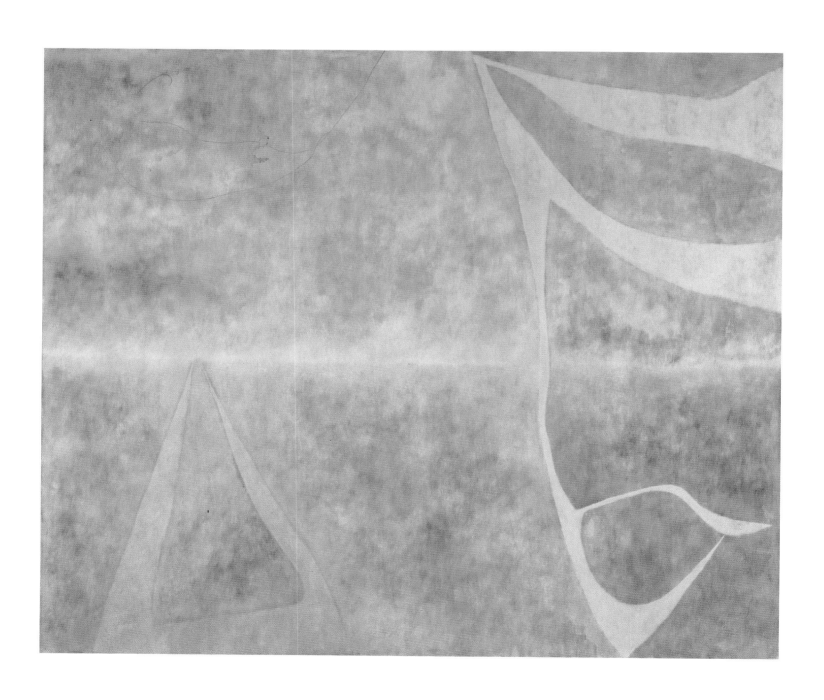

HARRY CALLAHAN

02. *Lake Michigan*, 1950
Gelatin silver print
5 × 6 ½ in (12.5 × 16.5 cm)

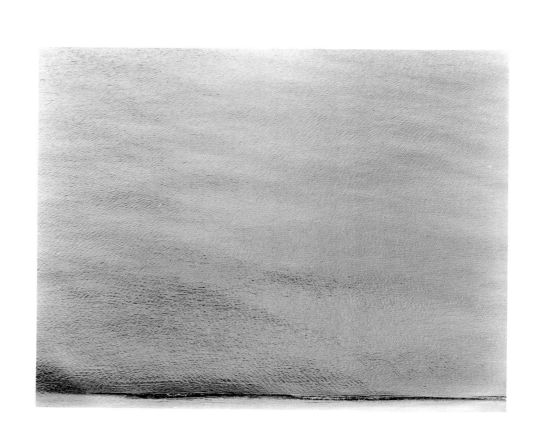

WILLEM DE KOONING

03. *Untitled*, 1961
Oil on canvas
80 × 70 in (203 × 178 cm)

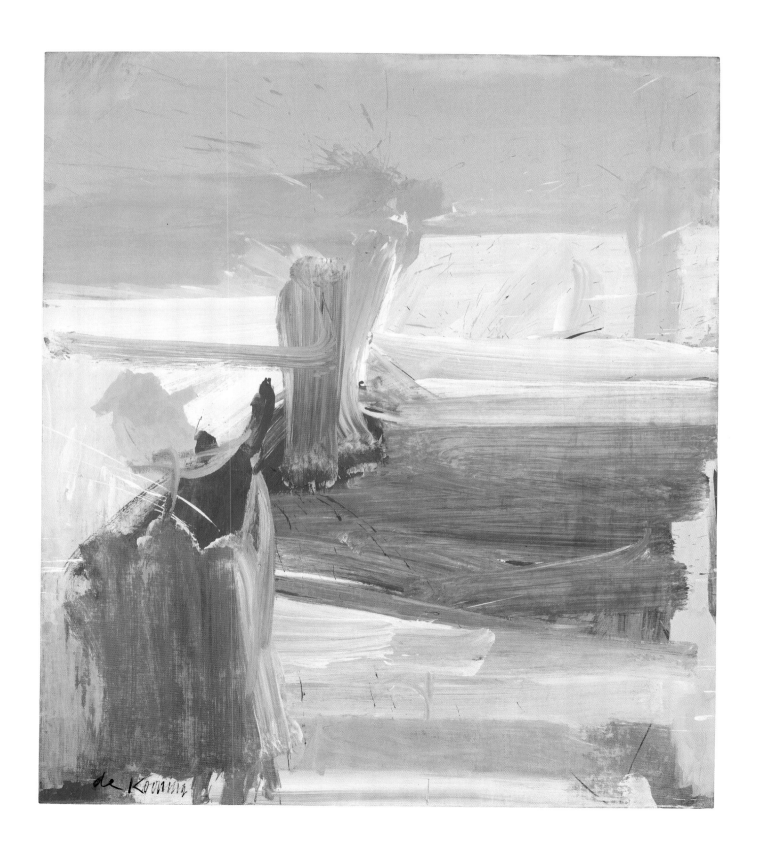

WILLEM DE KOONING

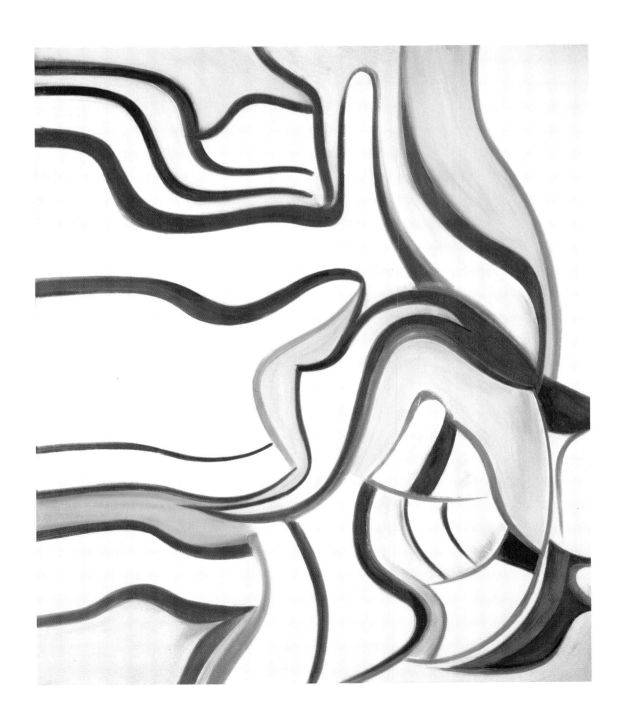

WILLEM DE KOONING

05. *Abstraction*, c.1949
Oil on canvas
24 ½ × 32 ½ in (62 × 82.5 cm)

06. *Untitled 11*, 1978
Oil on canvas
70 ¼ × 80 ¼ in (178.5 × 204 cm)

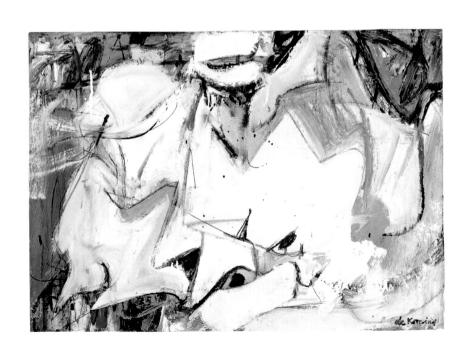

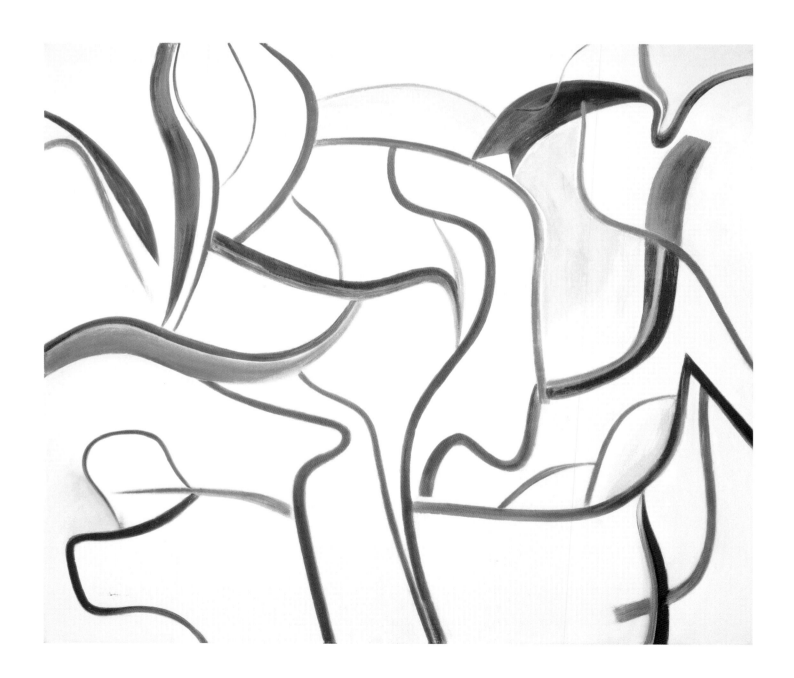

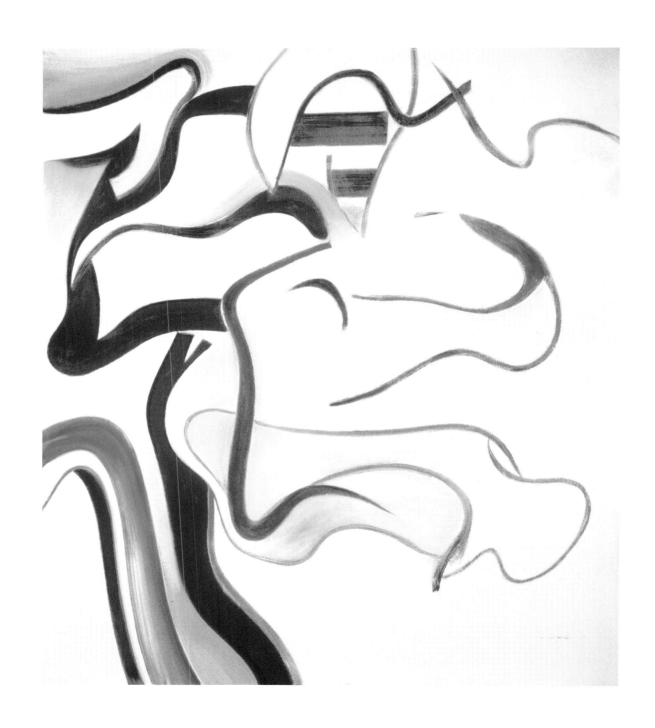

04. *Triptych (Untitled I, Untitled II, Untitled IV)*, 1985
Oil on canvas
Three panels. Left panel 80 × 70 in (203 × 178 cm);
central panel 77 × 88 in (195.5 × 452 cm); right panel
80 × 70 (203 × 178 cm)

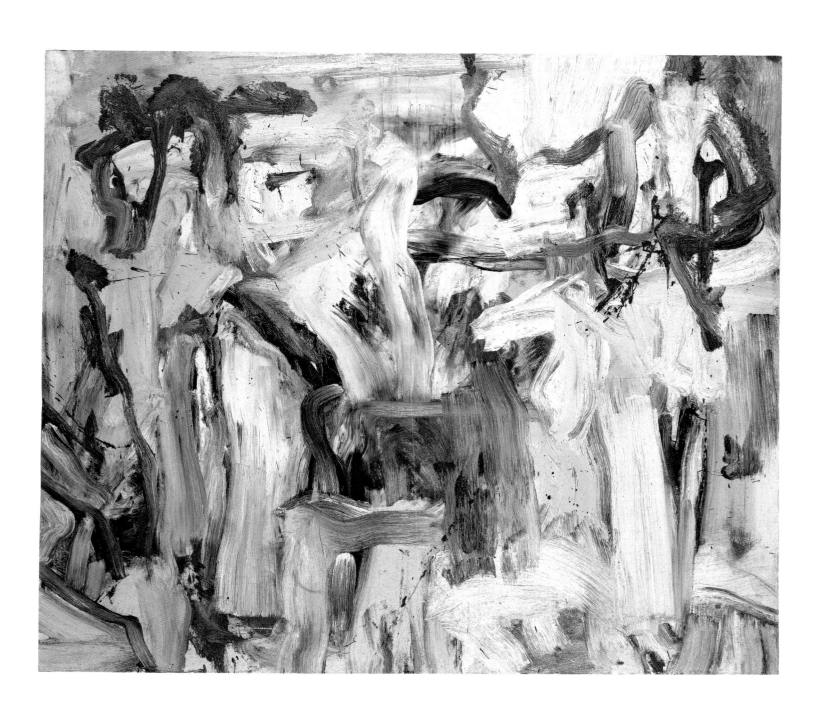

WILLEM DE KOONING

07. *Hostess*, 1973
Bronze
49 × 37 × 29 in (124.5 × 94 × 73.5 cm)

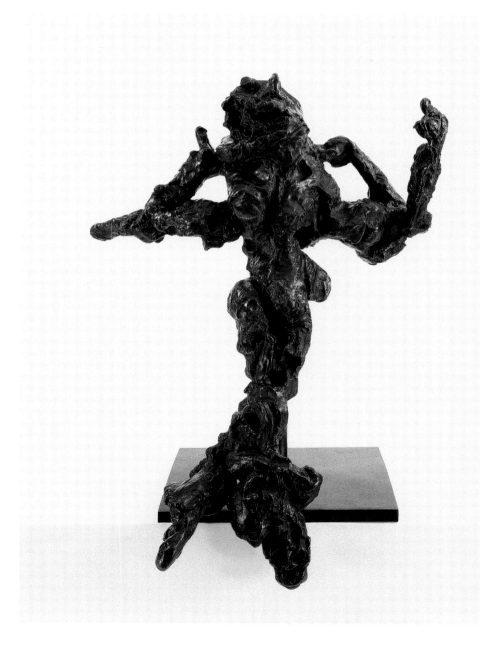

SAM FRANCIS

08. *Study for Shining Back*, 1958
Watercolor on paper
40 × 27 in (101.5 × 68.5 cm)

09. *Blue-Black*, 1952
Oil on canvas
117 × 76 ½ in (297 × 194.5 cm)

SAM FRANCIS

10. *Untitled*, 1959
Oil on canvas
96 × 116 ½ in (244 × 296 cm)

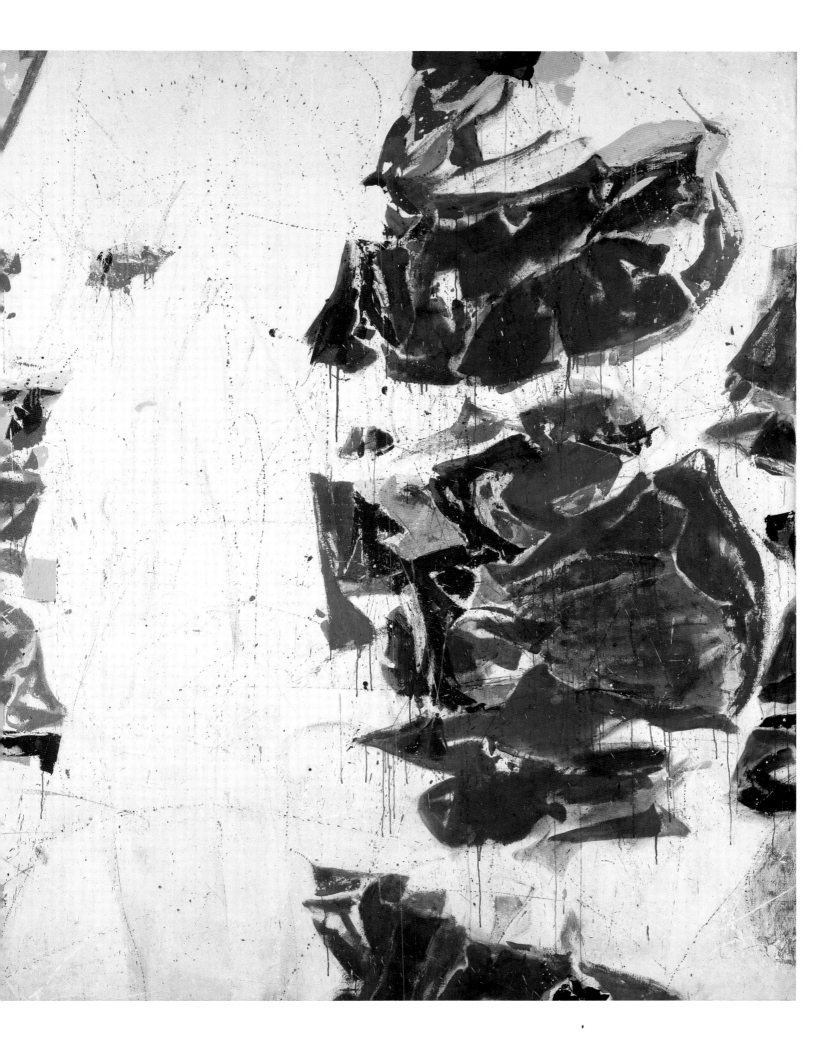

ARSHILE GORKY

11. *Untitled*, 1943
Graphite and wax pencil on paper
18 × 24 ½ in (45.5 × 62 cm)

12. *The Pirate I*, 1942 or 1944
Oil on canvas
29 × 40 in (75 × 104 cm)

ARSHILE GORKY

13. *Year after Year*, 1947
Oil on canvas
34 × 39 in (86.5 × 99 cm)

ADOLPH GOTTLIEB

14. *Composition*, 1945
Oil, gouache, casein and tempera on linen
29 ¾ × 35 in (75.5 × 89 cm)

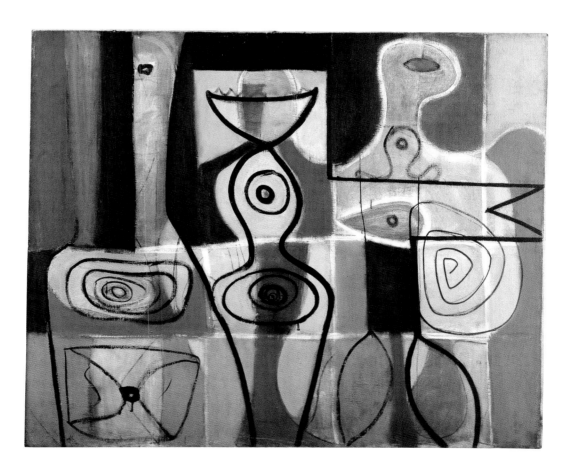

15. *Levitation*, 1959
Oil on linen
90 × 60 in (228.5 × 152.5 cm)

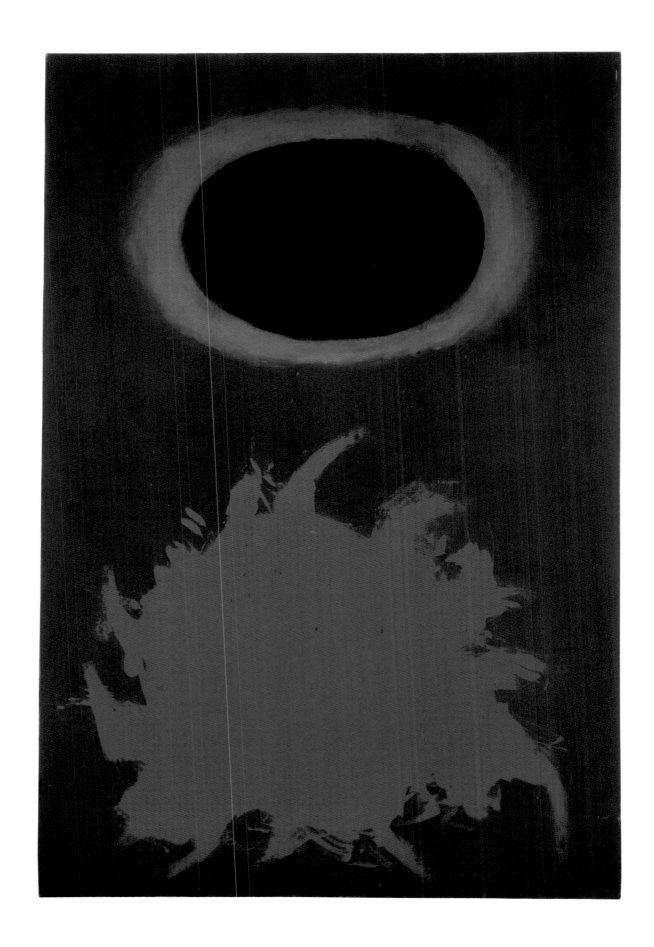

ADOLPH GOTTLIEB

16. *Green Turbulence*, 1968
Acrylic on canvas
94 × 157 in (239 × 399 cm)

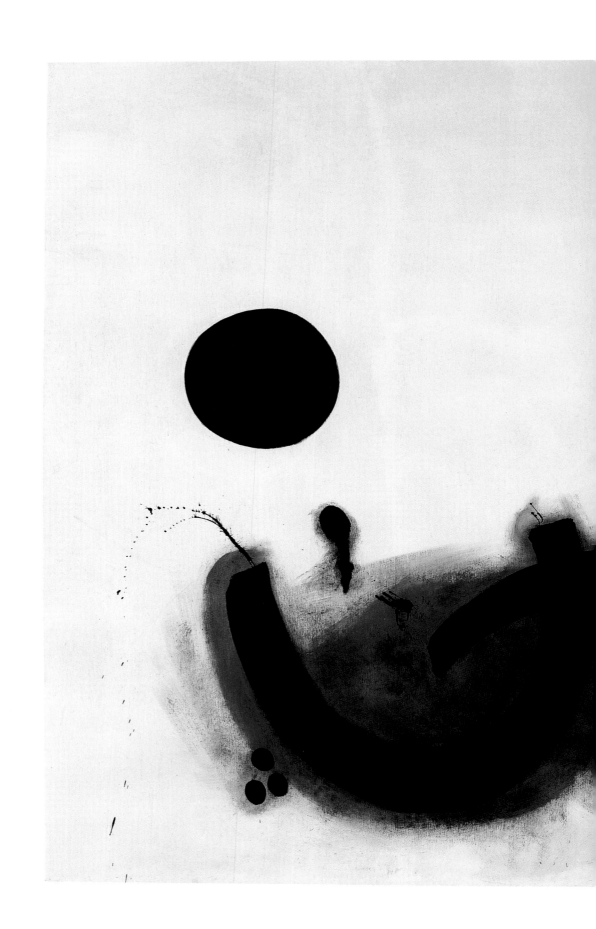

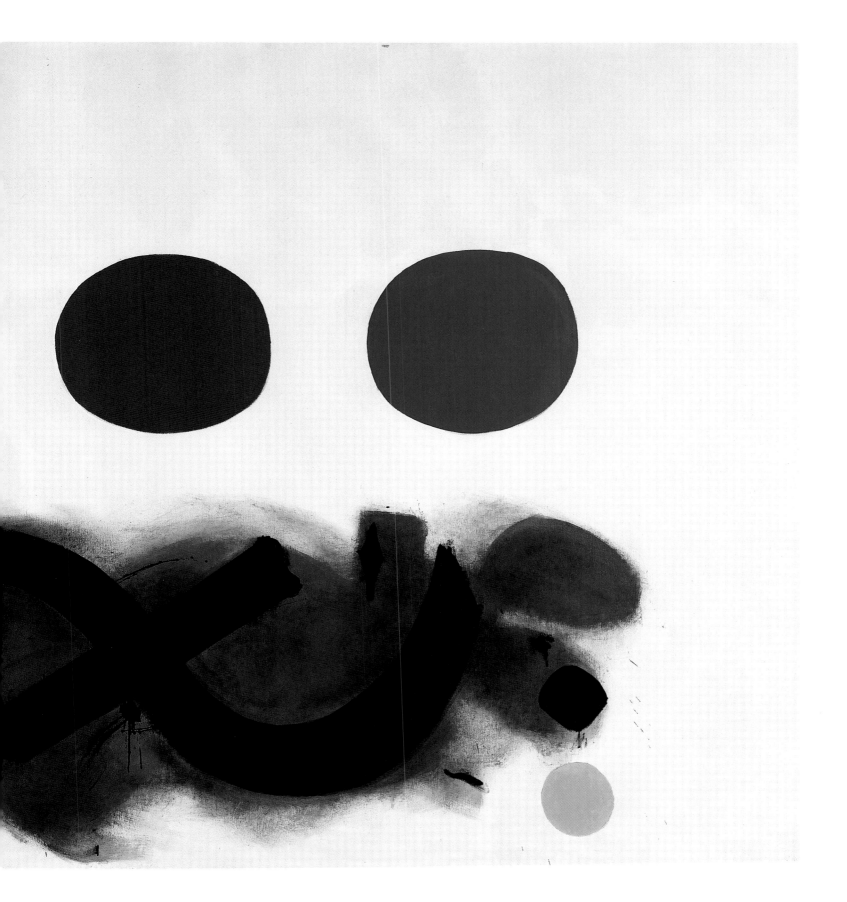

PHILIP GUSTON

17. *Downtown*, 1969
Oil on canvas
40 × 48 in (101.5 × 122 cm)

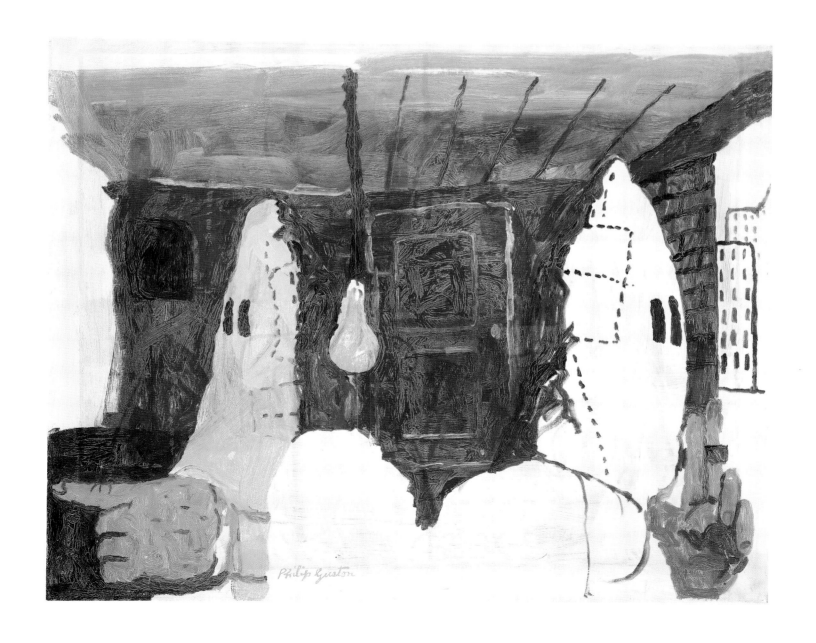

HANS HOFMANN

18. *Pagliaccio*, 1964
Oil on canvas
84 × 60 in (213.5 × 152.5 cm)

FRANZ KLINE

19. *Vawdavitch*, 1955
Oil on canvas
62 × 80 in (157.5 × 203 cm)

LEE KRASNER

20. *Untitled*, 1949
Oil on panel
48 × 24 in (122 × 61 cm)

LEE KRASNER

21. *Another Storm*, 1963
Oil on canvas
94 × 176 in (239 × 447 cm)

NORMAN LEWIS

22. *Untitled*, 1946
Oil on canvas
36 × 24 in (91.5 × 61 cm)

JOAN MITCHELL

23. *Untitled*, 1959
Oil on canvas
77 × 64 in (195.5 × 162.5 cm)

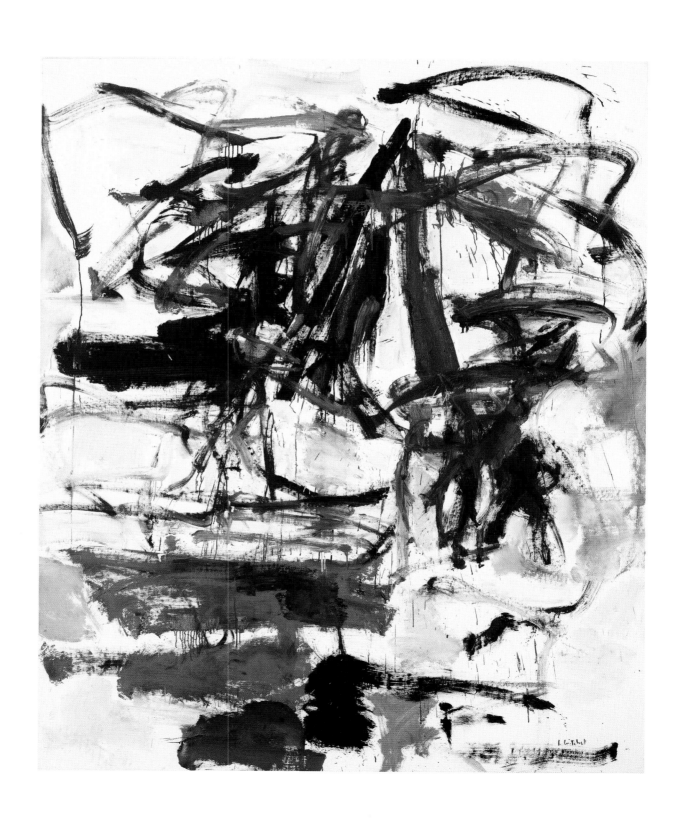

BARBARA MORGAN

24. *Pure Energy and Neurotic Man*, 1941
Gelatin silver print
19 × 15 ½ in (48.5 × 39.5 cm)

25. *Light Waves*, 1945
Vintage silver print (photogram)
9 ½ × 7 in (24 × 18 cm)

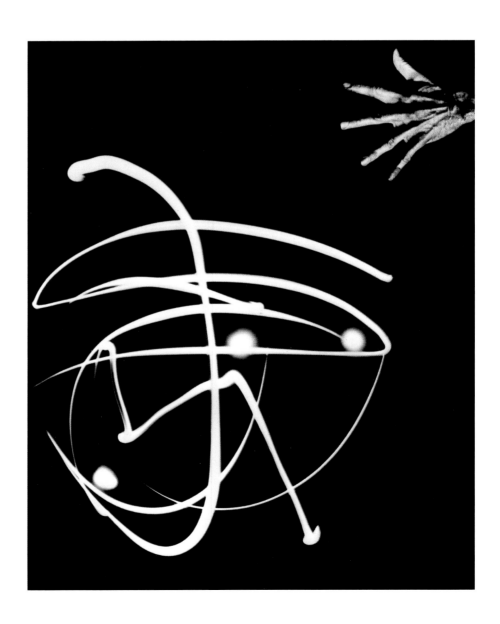

ROBERT MOTHERWELL

26. *Figure with Blots*, 1943
Oil, collage, gouache and charcoal on paper
45 ½ × 38 in (115.5 × 96.5 cm)

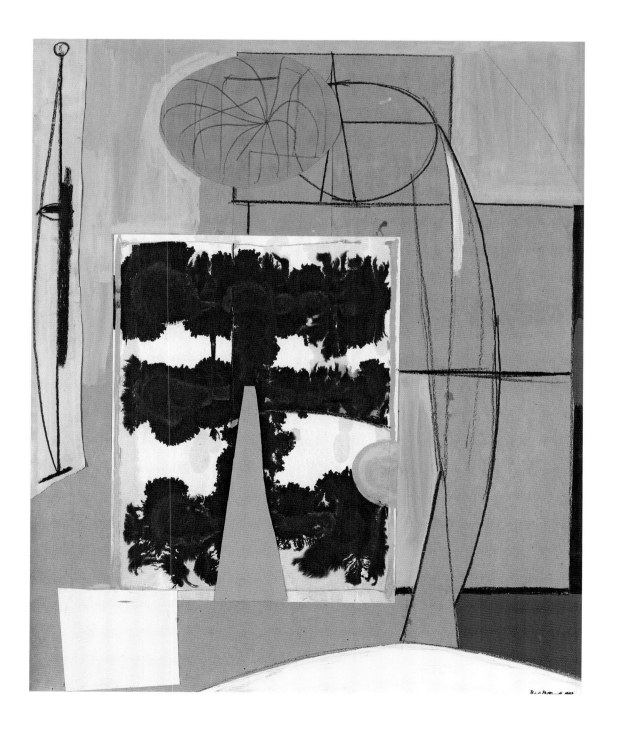

ROBERT MOTHERWELL

27. *Whatman Board Collage, PH-2-10*, 1966
Collage and oil on board
39 × 27 in (99 × 68.5 cm)

28. *Beside the Sea with Gauloises*, 1967
Oil on Strathmore paper with charcoal signature
30 × 25 in (76 × 63.5 cm)

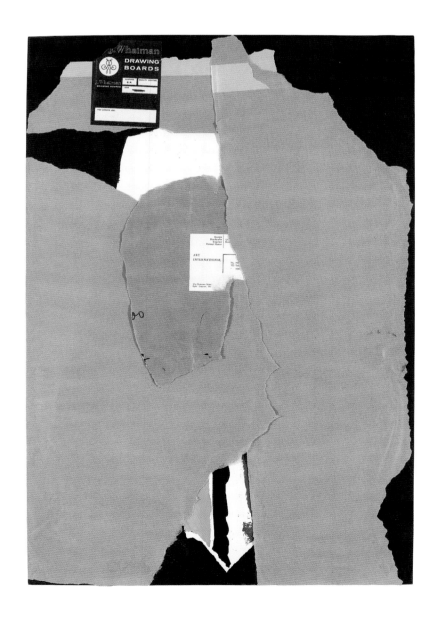

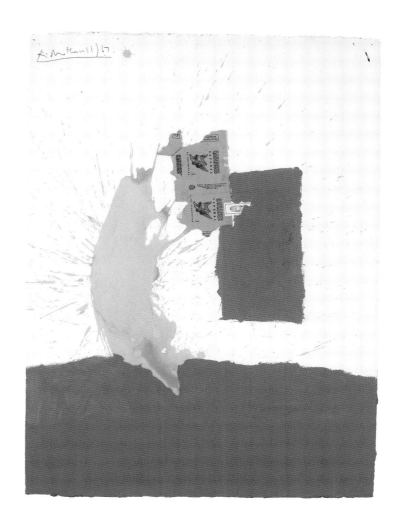

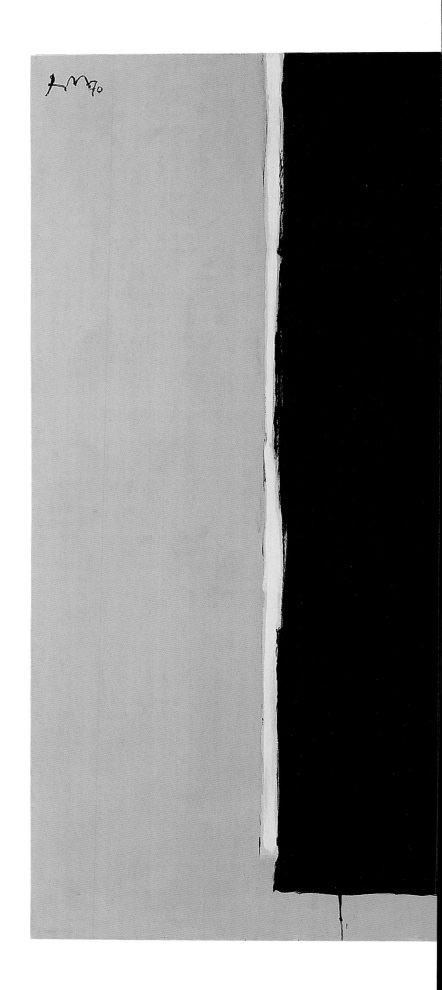

29. *Elegy to the Spanish Republic*, 1970
Acrylic on canvas
82 ½ × 188 ½ in (209.5 × 479 cm)

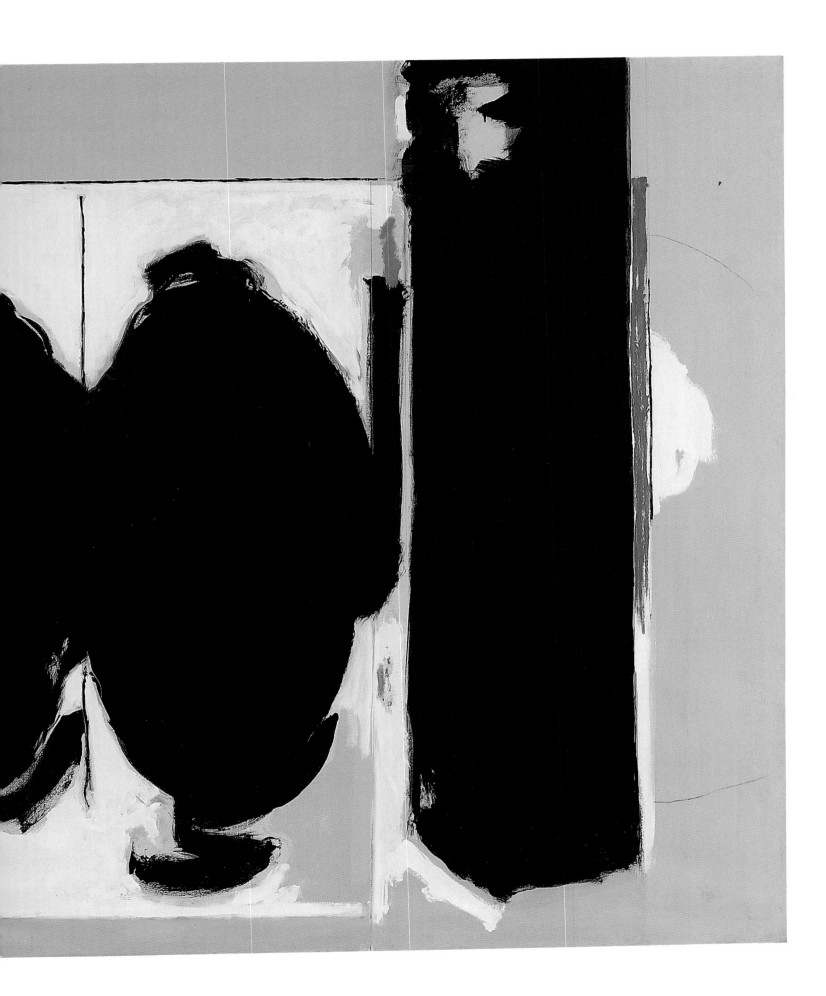

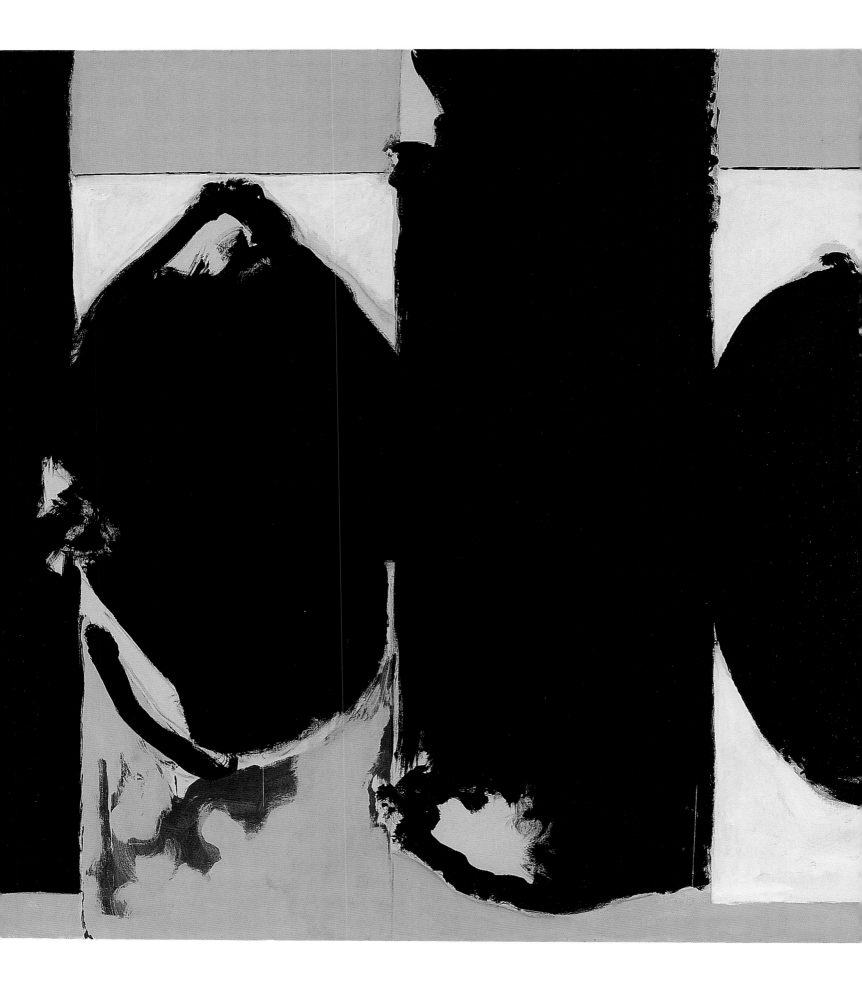

HANS NAMUTH

30. *Jackson Pollock*, 1950
Gelatin silver print
9 × 7 in (22.5 × 17.5 cm)

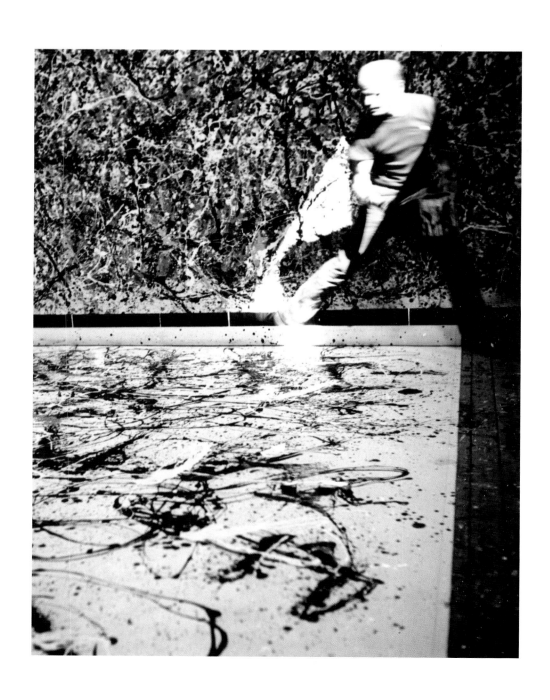

BARNETT NEWMAN

31. *Untitled*, 1948
Brush and black ink on heavy cream wove paper
24 × 16 ½ in (61 × 42 cm)

32. *Moment*, 1946
Oil on canvas
30 ⅛ × 16 in (96.5 × 40.5 cm)

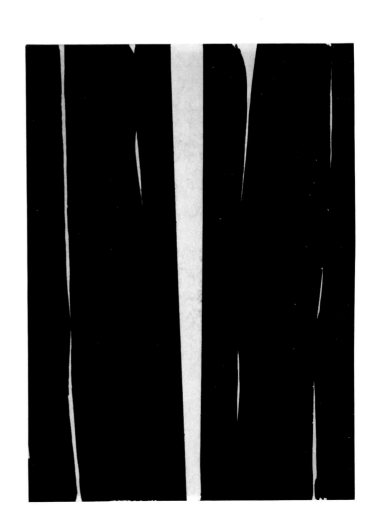

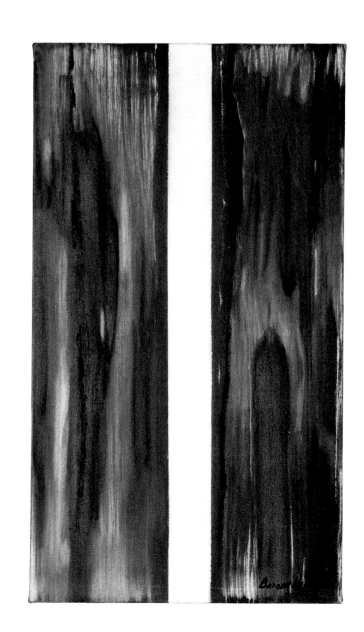

BARNETT NEWMAN

33. *End of Silence*, 1949
Oil on canvas
38 × 30 in (96.5 × 76 cm)

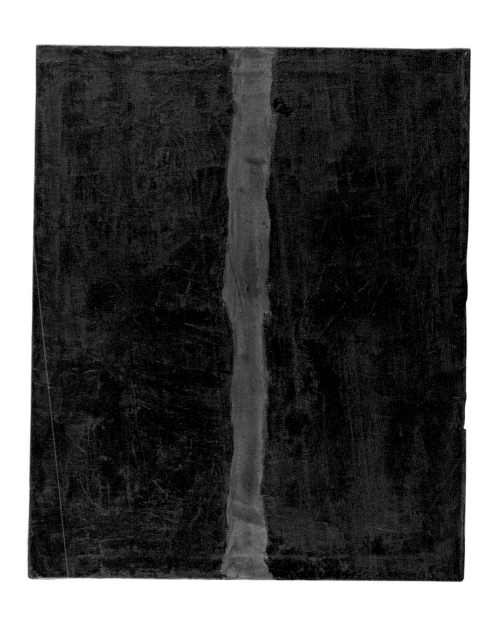

BARNETT NEWMAN

34. *Untitled*, 1949
Oil on canvas
74 × 29 in (188 × 73.5 cm)

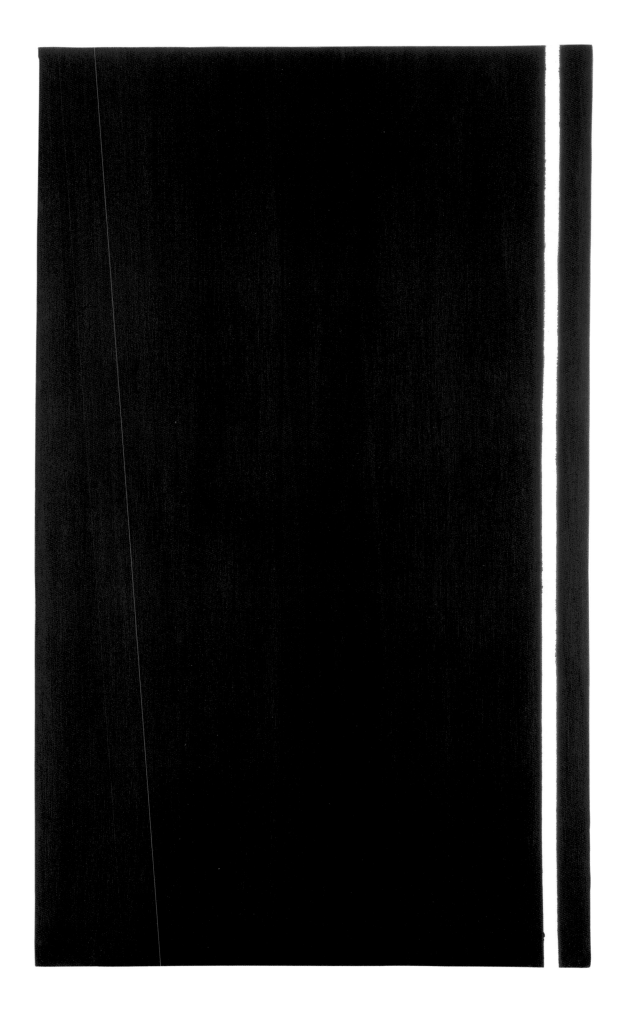

JACKSON POLLOCK

35. *Constellation (Accabonac Creek Series)*, 1946
Oil on canvas
22 × 18 ½ in (56 × 47 cm)

36. *Number 19, 1949*, 1949
Enamel on parchment mounted on composition board
31 × 22 ½ in (78.5 × 57 cm)

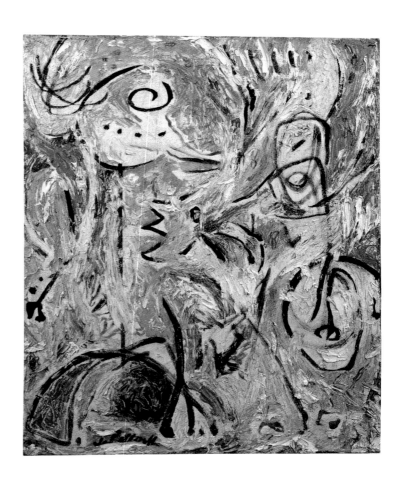

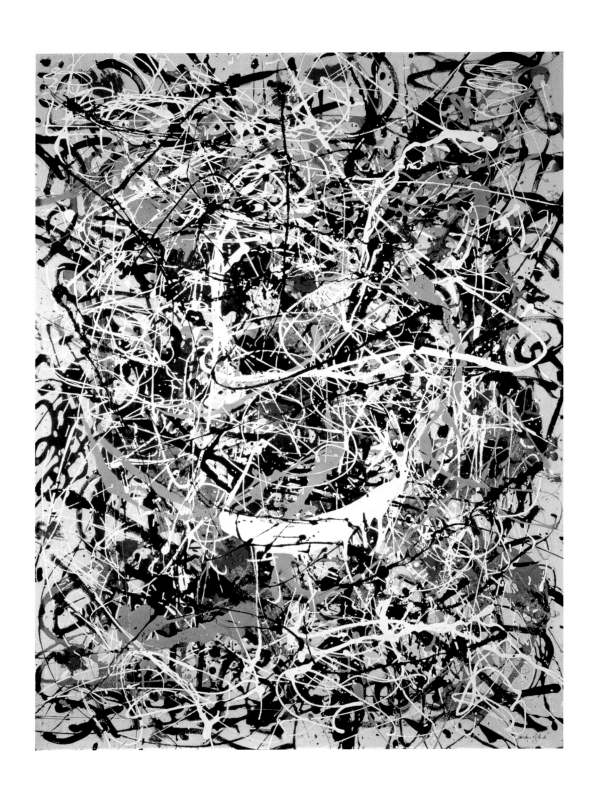

JACKSON POLLOCK

37. *Number 17, 1950 (Fireworks)*, 1950
Enamel and aluminum paint on composition board
22 ¼ × 22 ¼ in (56.5 × 56.5 cm)

38. *Untitled*, c.1951
Oil, enamel and pebbles on board
21 ¾ × 29 ½ in (55 × 75 cm)

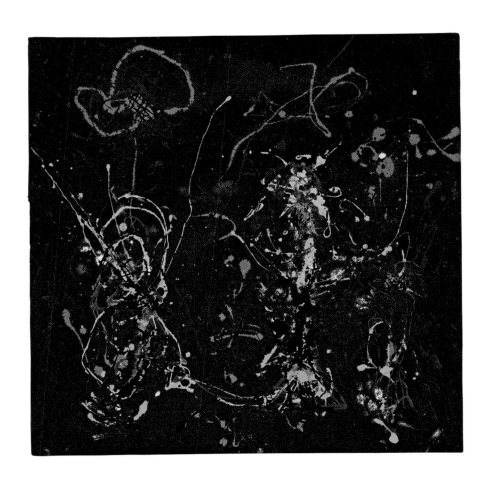

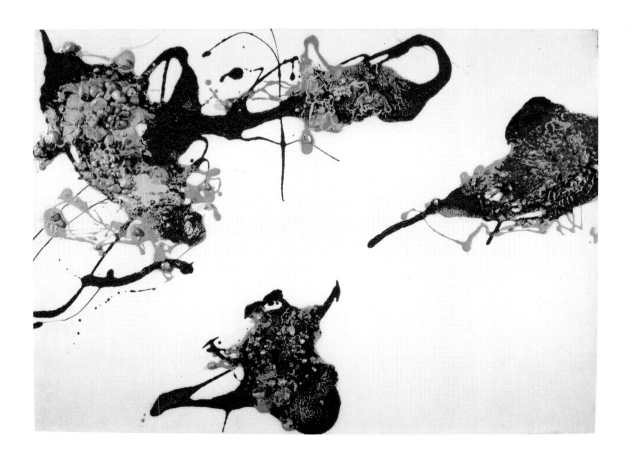

JACKSON POLLOCK

39. *Untitled*, 1951
Ink and gouache on paper
25 × 39 in (63.5 × 99 cm)

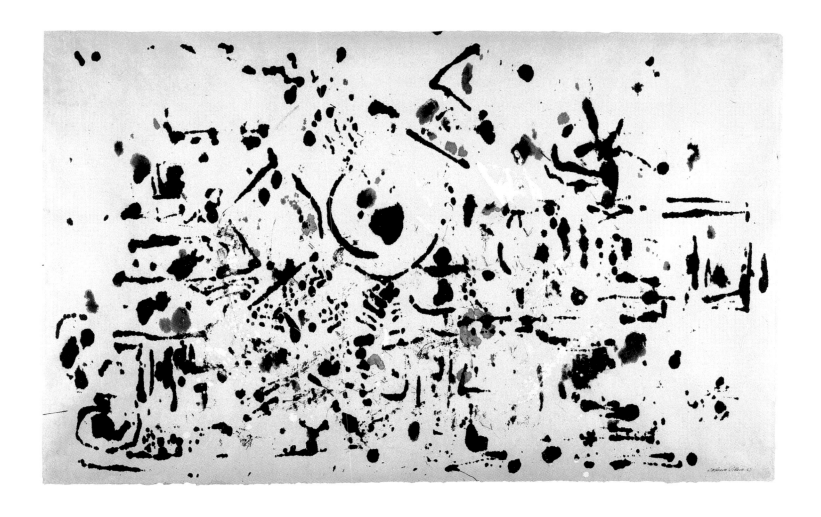

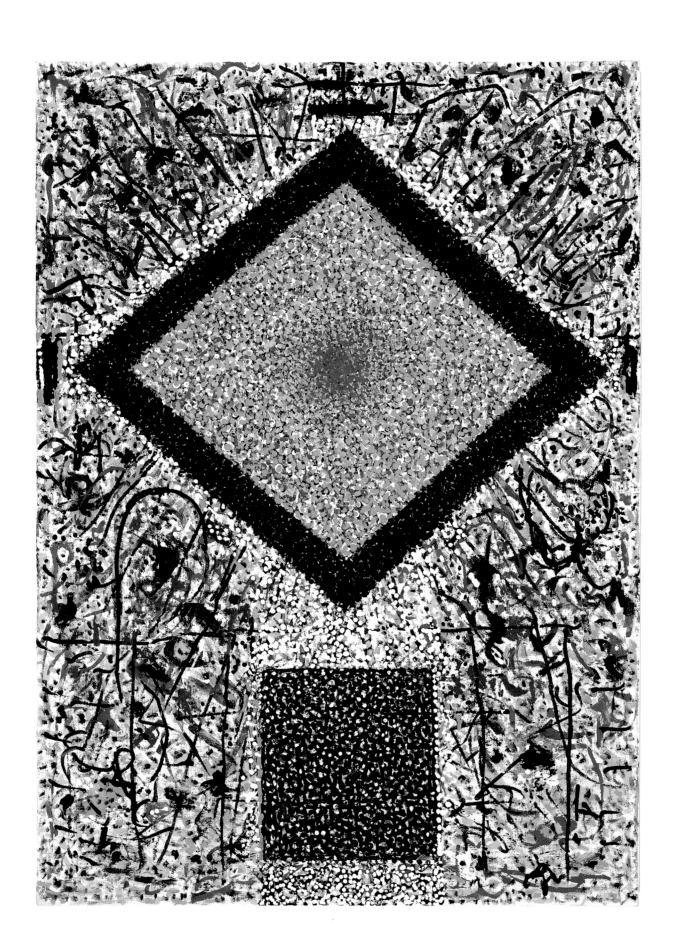

40. *Time is the Mind of Space, Space is the Body of Time*, 1979—82
Acrylic on linen
Three panels. Each panel
89 ½ × 62 ½ in (227.5 × 159 cm)

AD REINHARDT

41. *Untitled*, 1950
Gouache on paper
27 × 40 ¼ in (68.5 × 102 cm)

AD REINHARDT

42. *Red Painting*, 1952
Oil on canvas
60 × 82 in (152.5 × 208 cm)

MARK ROTHKO

43. *Untitled*, 1960
Oil on canvas
69 × 50 in (175.5 × 127 cm)

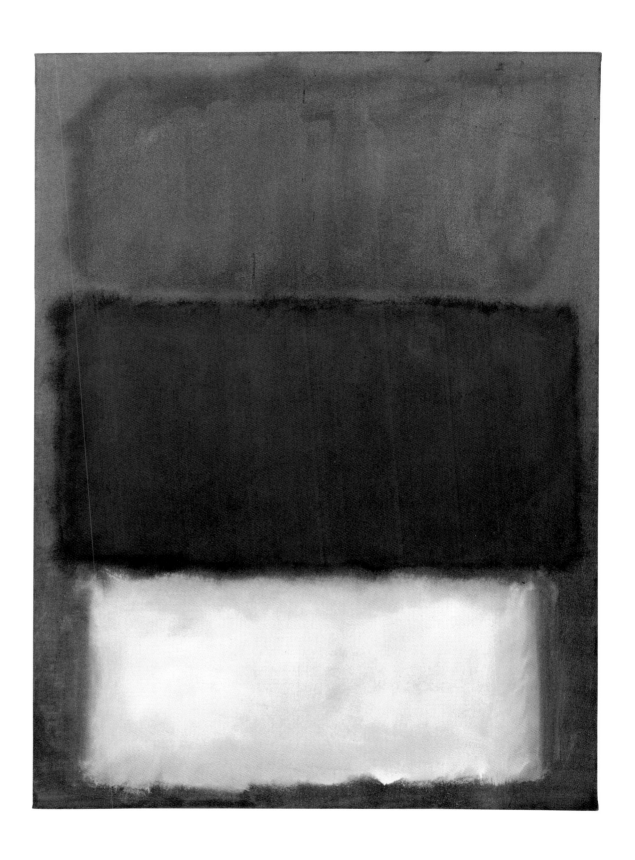

MARK ROTHKO

44. *Untitled*, 1968
Oil on paper mounted on canvas
39 ¾ × 25 ½ in (99 × 63.5 cm)

45. *Untitled*, 1968
Oil on paper mounted on canvas
38 ½ × 25 ½ in (99 × 63.5 cm)

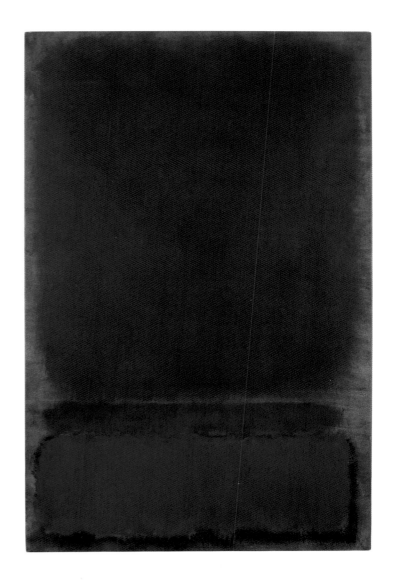

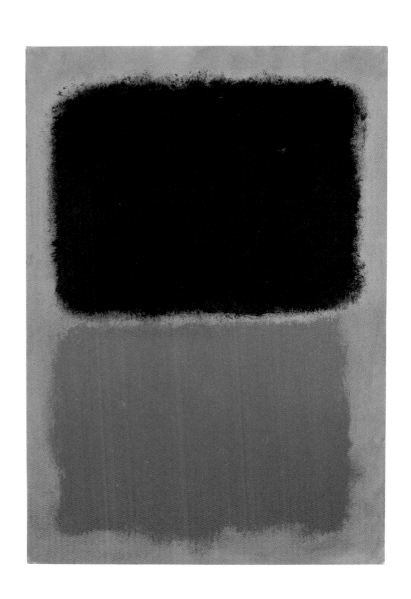

CHARLES SELIGER

46. *Multicellular Apparition*, 1946
Oil on canvas
28 ¼ × 22 ½ in (72 × 57 cm)

47. *Boundless Worlds*, 2001
Acrylic on masonite
10 × 18 in (25.4 × 45.5 cm)

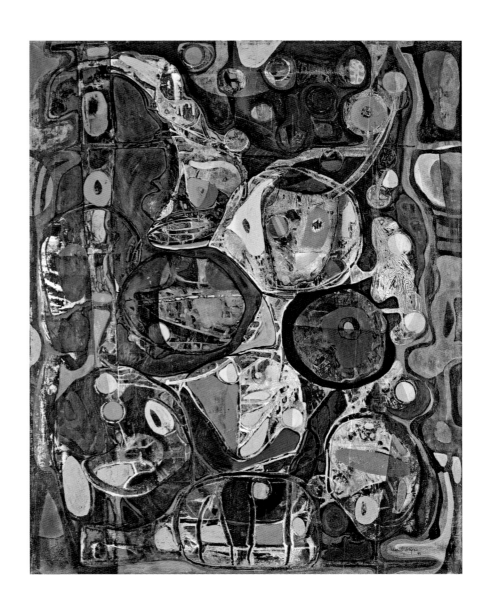

AARON SISKIND

48. *Jalapa 46 (Homage to Franz Kline)*, 1973
Vintage silver print
7 × 9 ½ in (18 × 24 cm)

49. *Chicago*, c.1948
Vintage silver print
24 × 20 in (61 × 51 cm)

DAVID SMITH

50. *Voltri II*, 1962
Steel
68 ½ × 59 ½ × 14 ½ in (174 × 151 × 37 cm)

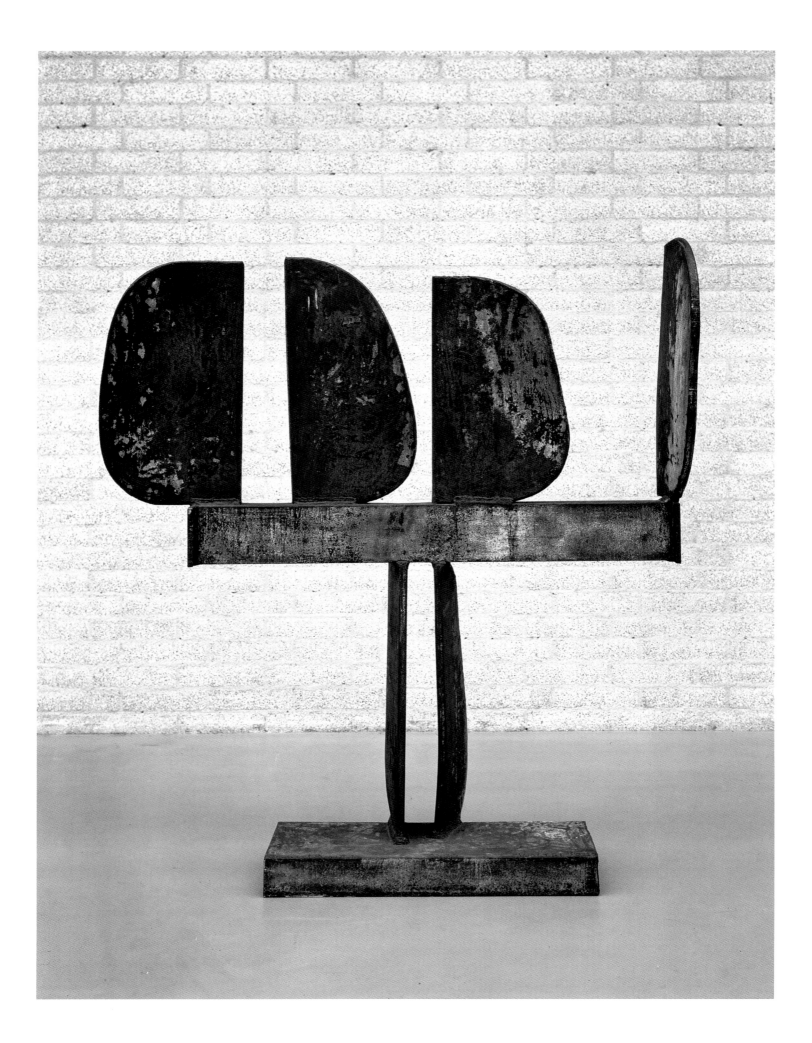

DAVID SMITH

51. *Voltri-Bolton V*, 1962
Steel dry-brushed with orange paint
81 × 41 × 11 in (205 × 104 × 28 cm)

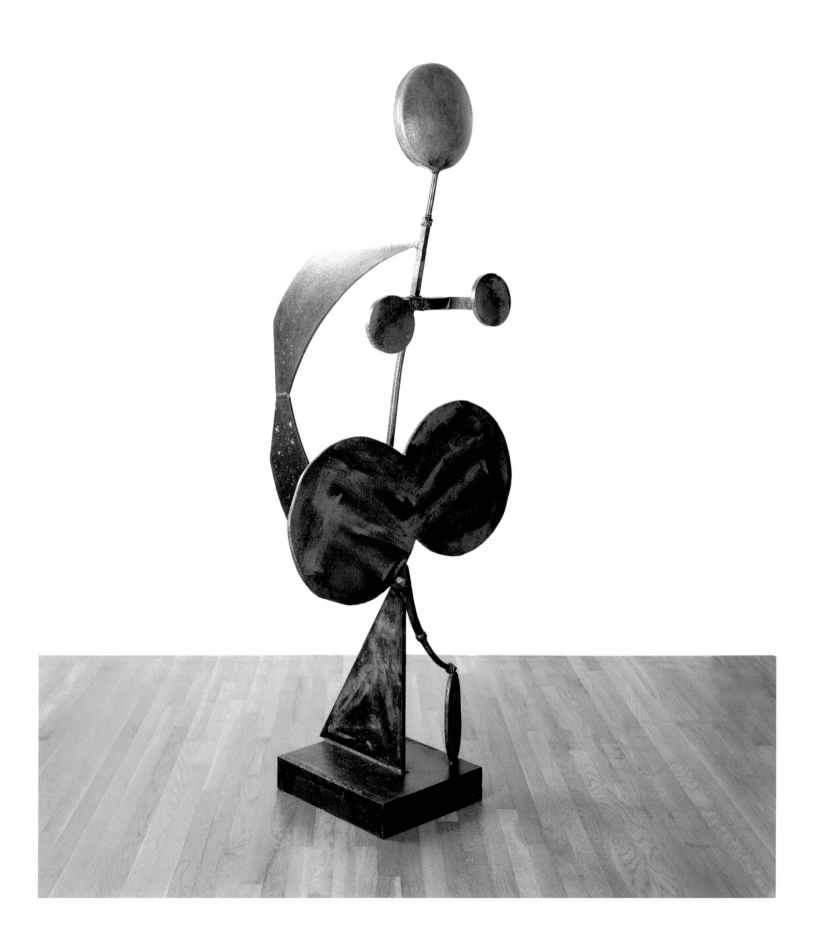

DAVID SMITH

52. *Tower Eight*, 1957
Silver
46 ½ × 14 × 10 ½ in
(118 × 35.5 × 26.6 cm)

53. *Voltri-Bolton X*, 1962
Steel
81 ¼ × 42 × 11 ¼ in
(206.5 × 106.5 × 28.5 cm)

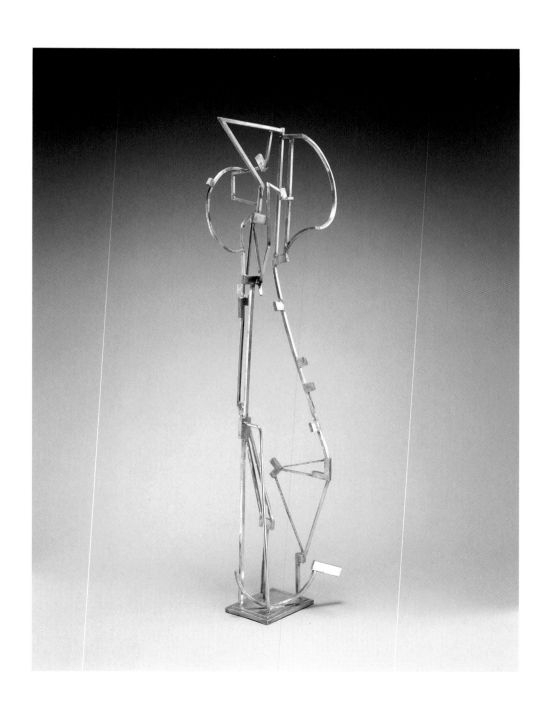

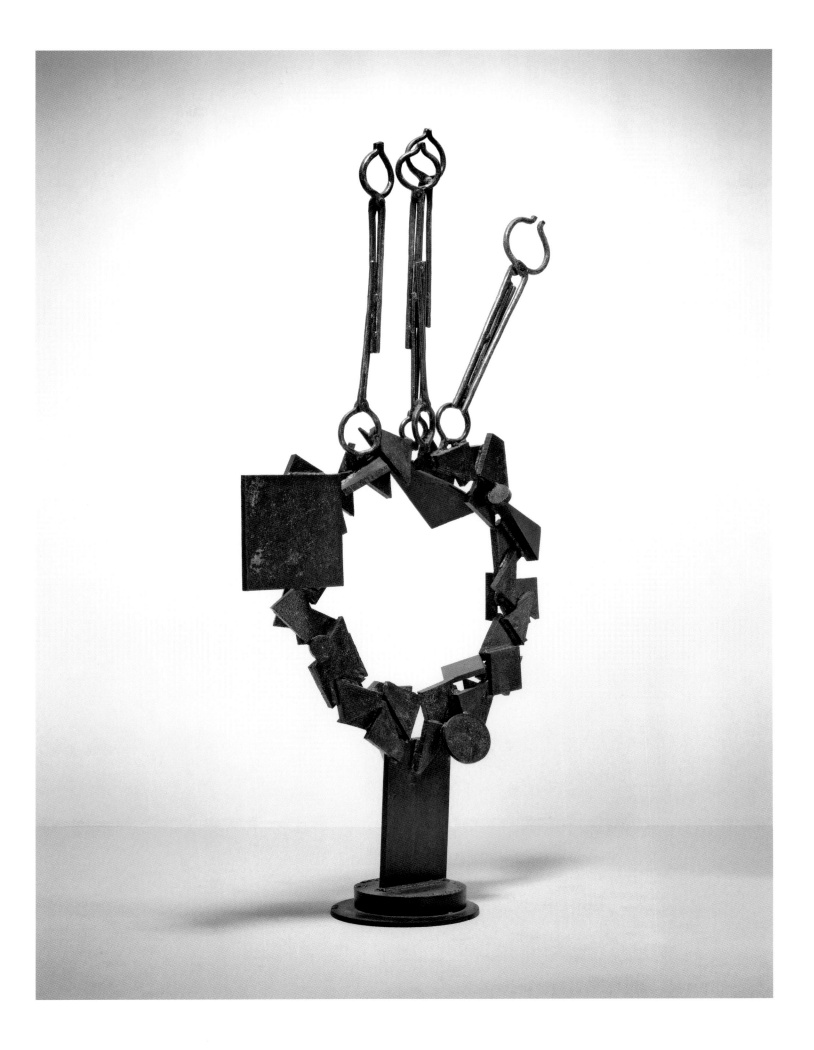

DAVID SMITH

54. *Forging XI*, 1955
Steel
91 × 8 ½ × 8 ½ in (231 × 21.5 × 21.5 cm)

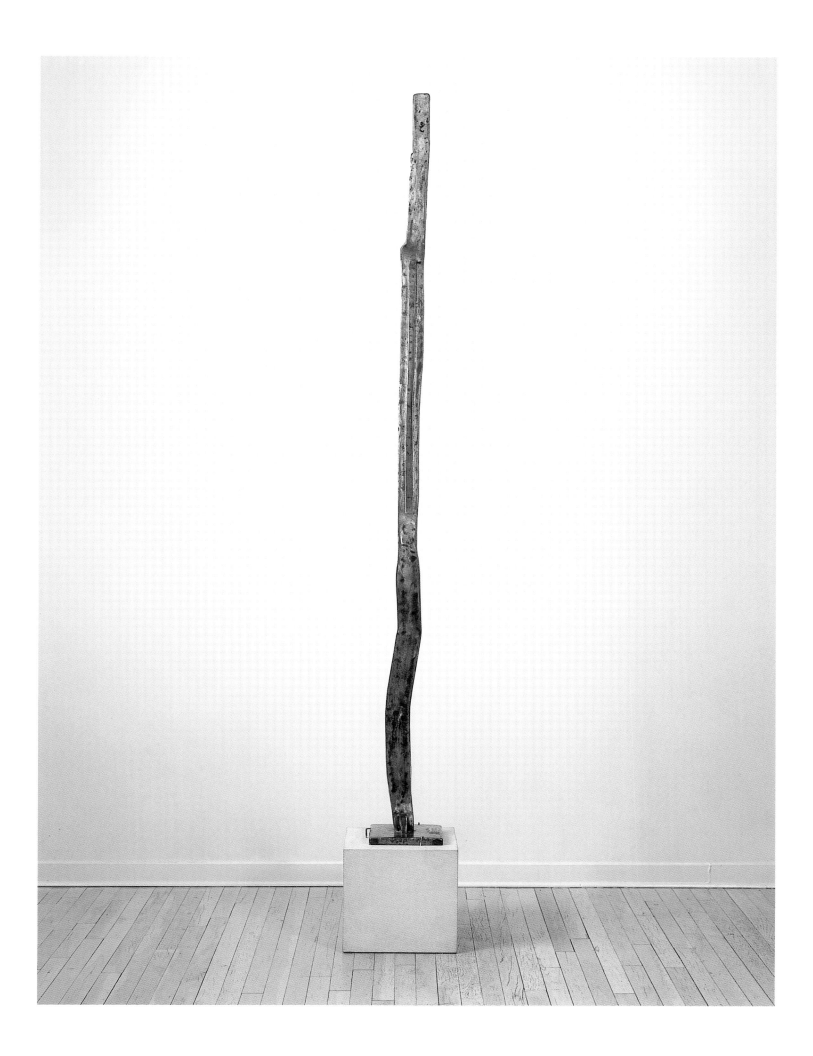

DAVID SMITH

55. *Seven Hours*, 1961
Painted steel
84 ¼ × 48 × 17 in
(214 × 122 × 43 cm)

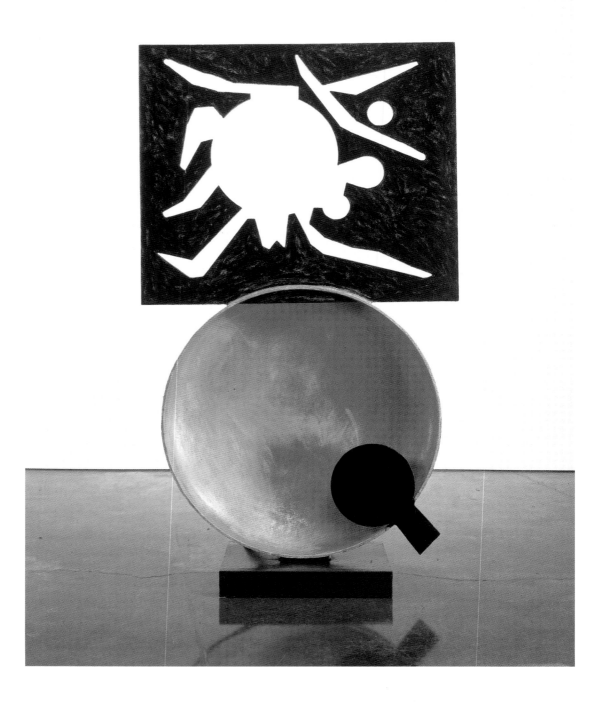

FREDERICK SOMMER

56. *Sumaré*, 1952
Gelatin silver print
7 ½ × 9 ½ in (19 × 24 cm)

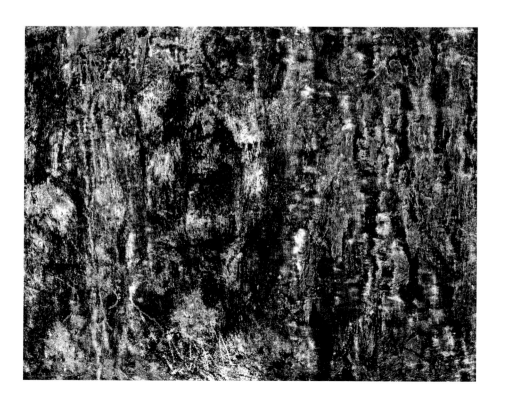

CLYFFORD STILL

57. *Untitled (PH-847)*, 1953
Oil on canvas
109 × 92 in (277 × 233.5 cm)

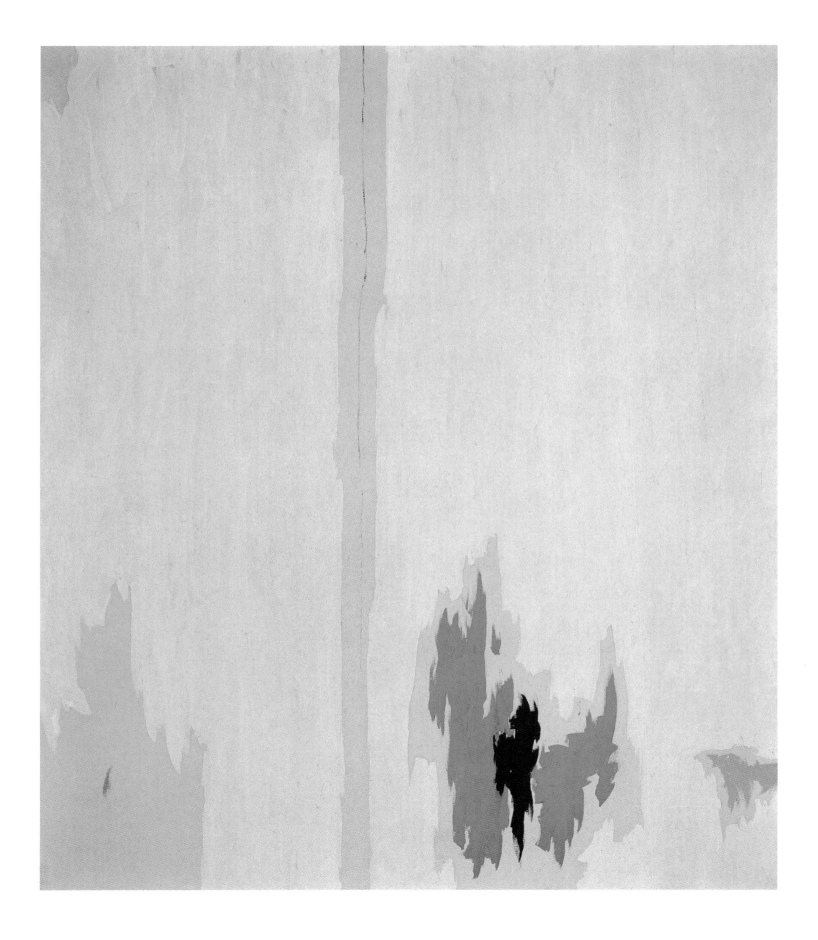

CLYFFORD STILL

58. *1955-M-No.2 (PH-776)*, 1955
Oil on canvas
114 × 96 in (289.5 × 244 cm)

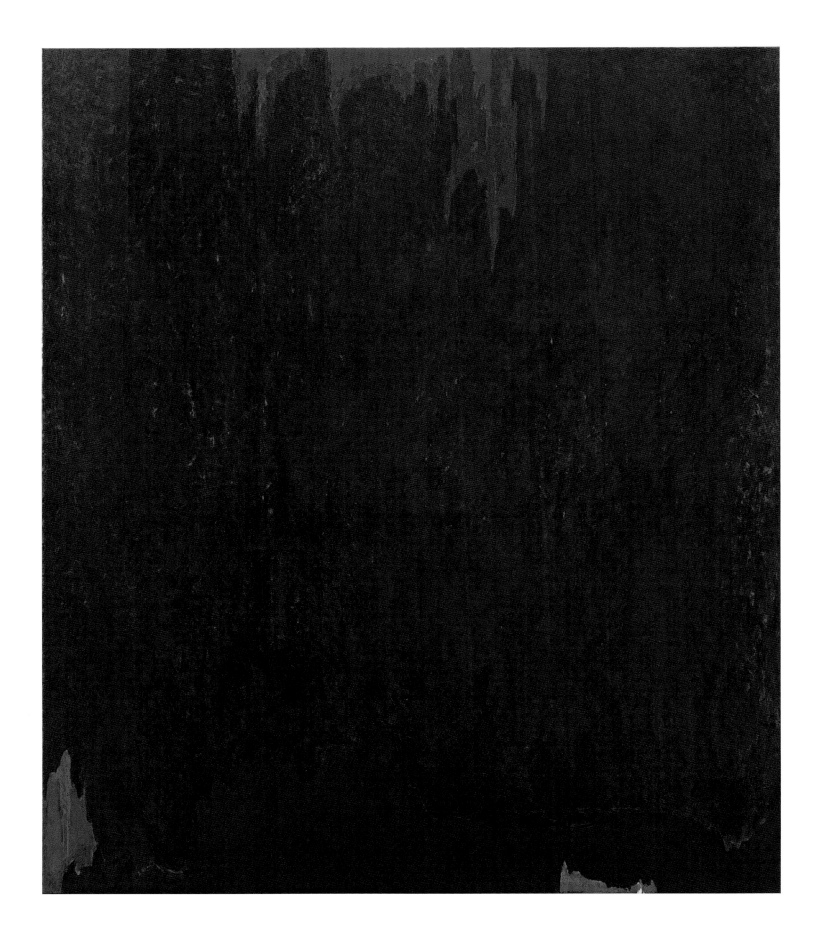

MARK TOBEY

59. *Yellow Harbor*, 1952
Tempera and crayon on brown paper
19 × 25 in (48.5 × 63.5 cm)

60. *Desert Town (Wild City)*, 1950
Oil and gouache on card mounted on masonite
43 × 27 in (109 × 69 cm)

JACK TWORKOV

61. *Idling II*, 1970
Oil on canvas
80 × 70 in (203 × 178 cm)

MINOR WHITE

62. *Surf, Vertical, San Mateo County, California*, 1947
Printed 1948
Gelatin silver print
4 ½ × 3 ½ in (11.5 × 9 cm)

BIOGRAPHIES

WILLIAM BAZIOTES (1912—63)

Vasillios Angelus Baziotes was born in Pittsburgh, Pennsylvania, on 11 June, 1912. The family moved to Reading, Pennsylvania, where, at Elm and Madison School (1925—28), Baziotes displayed only a limited penchant for study, preferring to box and indulge his interest in antiquity and the natural world that had been nurtured by his Greek-American parents.

Baziotes settled in New York in 1933 and enrolled at the National Academy of Design (1933—36), before tutoring at the Queens Museum (1936—38), and painting in the easel division (1938—41), both for the Works Progress Administration. By the early 1940s the Surrealist émigrés had influenced the primitivist, biomorphic vocabulary of his disquieting new works. These were displayed alongside Robert Motherwell's 'automatic' drawings in *First Papers of Surrealism* at the Whitelaw Reid mansion, New York, in 1942. Two years later, Peggy Guggenheim's Art of This Century held Baziotes's first solo show, followed in 1946 by an exhibition at the Kootz Gallery, which continued to represent him until 1958.

With Motherwell, Mark Rothko and David Hare, Baziotes set up the Subjects of the Artist School (1948). Thereafter, he taught at Brooklyn Museum Art School, New York University (1949—52), the People's Museum Art School of the Museum of Modern Art, (1950—52), and at Hunter College (1952—62). Simultaneously, his mature, opalescent style — part primeval odyssey, part a free flight of fantasy — reached its peak. Baziotes spent his last years with his wife Ethel in Morningside Heights, New York, and died on 6 June, 1963.

HARRY CALLAHAN (1912—99)

Harry Callahan was born in Detroit, Michigan, on 22 October, 1912. He studied engineering at Michigan State College, East Landing (1930—33), but took a job with Chrysler Motor Parts Corporation without graduating. He married Eleanor Knapp in 1936 and two years later bought his first camera. Callahan credited Ansel Adams — briefly his tutor at the Detroit Photo Guild (1941) — for what became his lucid, meticulous style. Though he abandoned formal training in 1941, his work is also indebted to László Moholy-Nagy, the German Bauhaus master, who hired him at the Institute of Design, Chicago (1946—61), before he moved to the Rhode Island School of Design, where he taught until retirement in 1973.

Callahan's subjects, chosen for their intimacy to his physical and emotional environment, range from landscape — treated as near-abstract essays in light, rhythm and space — to poignantly bare family portraits. In 1962 the Museum of Modern Art held a joint exhibition with Callahan and Robert Frank; in 1976 it organized a major solo retrospective. Having traveled through Europe and North America, Callahan experimented towards the end of his career with color film, though his focus remained the human figure. He was the first photographer to represent the United States at the Venice Biennale (1978) and received numerous distinctions, including the Distinguished Career in Photography Award from the Friends of Photography, Carmel, California (1985), and the National Medal of Arts (1996). He established the Callahan Archive at the Center for Creative Photography in Tucson, Arizona, before his death in Atlanta, Georgia, on 15 March, 1999.

WILLEM DE KOONING (1904—97)

Willem de Kooning was born in Rotterdam, The Netherlands, on 24 April, 1904. He trained at the Rotterdam Academy of Fine Arts and Techniques (1916—24), was an avid reader of *Wendingen*, an Amsterdam School periodical, and absorbed the principles of both the Jugendstil and de Stijl movements. In 1926 he sailed as a stowaway to the United States, settling in Manhattan in 1927, where he worked illegally as a sign painter and artist.

De Kooning designed murals for the Works Progress Administration from 1935 to 1939, and in 1942 married the artist Elaine Fried. His first solo show was at Charles Egan Gallery (1948), by which time his painstaking figurative and abstract tendencies had merged into an urgent, hybrid idiom. However, violent figuration re-surfaced in his *Woman* series, shown at Sidney Janis Gallery (1953), which caused a sensation, as much for their subject-matter as for the coruscating gestural brushwork that appeared to lay bare the artist's working process. Thereafter, de Kooning exhibited regularly in Manhattan: again at Sidney Janis (1956, 1959), and in a two-man show with Barnett Newman at Allan Stone Gallery (1962).

Naturalized as an American citizen in 1962, de Kooning relocated to Springs, Long Island, in 1963 and the next year received the Presidential Medal of Freedom. His major retrospectives included those held at the Stedelijk Museum, Amsterdam (1968) and the Museum of Modern Art the same year. It was during this late period that de Kooning turned to sculpture, creating grotesque malleable-looking figures. Meanwhile, his pictorial style had progressed from savage urban landscapes to more lyrically rendered pastorals and, ultimately, the ghostly sparseness of his final canvases. Having suffered from Alzheimer's disease, de Kooning died on Long Island on 19 March, 1997.

SAM FRANCIS (1923—94)

Sam Francis was born on 25 June, 1923, in San Mateo, California. He studied medicine at the University of California at Berkeley (1941—43) and then joined the United States Army Corps. While convalescing in hospital from a severe injury, Francis began painting. Upon returning to Berkeley (1948—50) he gained a Masters degree in art, before moving to Paris, where he met exponents of Art Informel. There, he showed his own vibrantly hued, dense paintings at the Galerie du Dragon in 1952. Between travels to Venice, New York, Mexico and Hong Kong, Francis had a museum show in 1955 at the Kunsthalle in Bern,

Switzerland. Success in America followed, including a solo show at Martha Jackson Gallery (1956), and participation in the *Twelve Americans* exhibition at the Museum of Modern Art the same year.

As a European expatriate and West Coast native, Francis was a relative outsider to the New York scene. Nevertheless, his cell-like, intricate compositions took the imagery and colorism of Mark Rothko and Clyfford Still forward into a second-generation. Plagued by illness, while in hospital in Bern in 1961, Francis experimented with watercolor: the results led to an increasingly vacant white field, activated at the margins with luminous color. The vision of an empyrean void haunted Francis's imagination.

In 1962 Francis and his third wife, Teruko Yokoi (divorced 1963), set up home in Santa Monica. The Museum of Fine Arts, Houston, organized a major traveling retrospective in 1967. Francis's calligraphic, dynamically structured works were seen regularly throughout the United States, Europe and in Japan during the rest of his career, while he also executed murals, including those for the courthouse in Anchorage, Alaska (1980). He died in Santa Monica on 4 November, 1994.

ARSHILE GORKY (1904—48)

Vosdanik Manoog Adoian was born in Khorkom, eastern Armenia, on 15 April, 1904. His father moved to Providence, Rhode Island, in 1906, but he and his siblings remained with his mother. He learned vernacular Armenian at St. Vardan's Armenian Apostolic School and classical Armenian at home. Following the Turkish invasion in 1918 and his mother's death, he and his sisters arrived at Ellis Island in February 1920. Fired from the Hood Rubber Company, Massachusetts, for drawing on the equipment, Gorky went to the New School of Design in Boston. Here he painted *Park Street Church* (1924), signing it 'Gorky, Arshele', the first of many pseudonyms : Arshile is the Caucasian form of Arshak, the Armenian royal name; Gorky is Russian for 'bitter one'.

As Arshile Gorky, he bought a studio in New York (1925) and was appointed at the Grand Central School of Art, where he taught and painted (1926—31). One of his Cubist-influenced paintings was included in a show at the Museum of Modern Art as early as 1930; his first solo show was held three years later at the Mellon Galleries, Philadelphia. He worked for the mural division of the Works Progress Administration from 1935 to 1941, having become a naturalized United States citizen in 1939.

After marrying Agnes Magruder in 1941, Gorky's art gradually left Surrealism and other sources behind until it achieved a unique synthesis of sinuous draftsmanship, a luscious palette and highly evocative imagery that camouflaged allusions to landscape and the body. In 1945 he held a landmark show of paintings and drawings at Julien Levy Gallery. However, after a sequence of personal tragedies Gorky committed suicide in Sherman, Connecticut, on 21 June, 1948.

ADOLPH GOTTLIEB (1903—74)

Adolph Gottlieb was born in the Bronx, to Austrian-Hungarian parents on 14 March, 1903. Restless and independent, he quit high school in 1919 to enroll at the Art Students League. At eighteen, Gottlieb left for Paris and took life-drawing classes at the Académie de la Grande Chaumière. He returned to New York in 1923 to study art at Parsons School of Design, Cooper Union, and the Art Students League. With echoes of Cézanne, his portraits and outdoor scenes won a joint prize in the Dudensing National Competition (1929). Gottlieb married Esther Dick in 1932, joined the easel division of the Works Progress Administration in 1936, and co-founded the progressive group The Ten (1935—40).

After a year in Tucson, Arizona, Gottlieb returned to New York in 1939. By then, Gottlieb had absorbed a wide range of sources — encompassing African and Native North American Indian art, the Renaissance and Surrealism. The archaic, esoteric ciphers of his compartmentalized *Pictographs* followed, and were shown in a solo exhibition at Artists' Gallery (1942). The so-called *Imaginary Landscapes* of the early 1950s synthesized the earlier grids into two dramatically opposed tiers. This process continued in tandem with an increasing tendency towards energetic simplification. In the *Bursts* (first shown in 1957 at Martha Jackson Gallery), these dualities reached their fullest expression — itself further distilled to crisp essences in his subsequent works. The Whitney Museum of American Art and the Solomon R. Guggenheim organized a simultaneous retrospective in 1968. Despite a stroke in 1970 that paralyzed his left side, Gottlieb continued to paint until his death on 4 March, 1974.

PHILIP GUSTON (1913—1980)

Philip Goldstein was born on 27 June, 1913, in Montreal, Canada, the son of Russian-Jewish immigrants from Odessa. The family moved to Los Angeles seven years later, but Philip's father, a blacksmith, struggled to find work and committed suicide in 1923 or 1924 (the exact date is uncertain). His mother Rachel raised the seven children and nurtured his interest in the visual arts.

A sophisticated draftsman, Guston early on relished George Herriman's irreverent comic strip *Krazy Kat*. Such cartoons would influence not only his eye for graphics, but also his instincts as a satirist. He was expelled from Manual Arts High School for distributing subversive leaflets with classmate Jackson Pollock. Thereafter, he pursued his interest in art independently, immersing himself in the old masters, particularly Uccello and Piero della Francesca.

In the 1930s Guston became increasingly suspicious of the notion of 'art for art's sake': his politics and art coalesced. He turned to mural painting and his first depictions of the hooded Ku Klux Klansmen. He moved to New York in the winter of 1935—36, where he joined the circle of what would become

Willem de Kooning,
East Hampton studio.
March 26, 1978

Adolph Gottlieb,
in his studio.
February 16, 1962

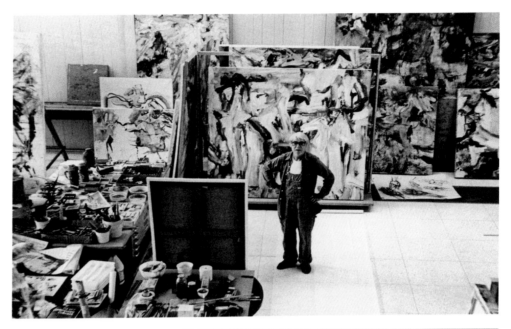

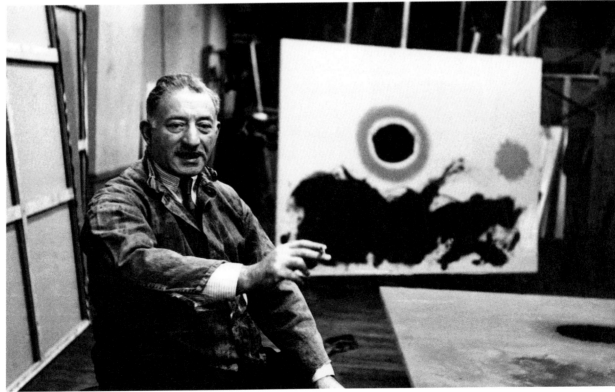

the Abstract Expressionists. His first solo exhibition was in 1945; the same year he won a first prize award from the Carnegie Institute in Pittsburgh. In 1948 he went to Europe, studying the Italian, French and Spanish masters first hand — having won the Prix de Rome from the American Academy, Rome.

The two key shifts in Guston's career involved a move from symbolic figuration to enigmatic abstraction in the late 1940s, and his ultimate return to representation from 1967 onwards when he lived in rural New York State. The earlier phase, characterized by thickly textured pinks, reds, and grays agglomerating towards the center of the canvas, mingled the gestural and chromatic impulses in Abstract Expressionism. However, his brutish late vocabulary — deploying cyclopean heads, hoods, massed legs, and everyday objects — first shown in New York in 1970, seemed to many a betrayal of avant-gardism itself. These melancholic allegories, with their mixture of manic absurdity and dire existentialism, exerted great influence on a younger generation. Guston died in Woodstock, New York, on 7 June, 1980.

HANS HOFMANN (1880—66)

Johann Georg Hofmann was born in Weissenburg, Bavaria, on 21 March, 1880. In 1886, his family relocated to Munich following his father's appointment to work for the government. His talent for mathematics, science, and visual art was evident at a young age and by the time he was sixteen he too assisted the Bavarian government.

Despite various scientific achievements, Hofmann gravitated to art and attended Moritz Heymann Art School from 1898 onwards. The patronage of Phillip Freudenberg, a Berlin art collector, enabled him to move to Paris in 1904, where he spent a decade, studying at the Académie Colarossi and the Académie de la Grande Chaumière, and also informally in the company of Picasso, Braque and Robert Delaunay: the latter's stress on chromatic relations over drawing proved a lasting influence.

After exhibiting with the New Secession group in 1909, Hofmann had his first solo show at Berlin's Galerie Paul Cassirer (1910). He established the Hans Hofmann School of Fine Arts in Munich in 1915, married his long-time partner Maria (Miz) Wolfegg in 1924, and permanently moved to America in 1931 to teach at the University of California at Berkeley. There, his first exhibition was at the California Palace of the Legion of Honor (1931), after which he moved to New York to open another School of Fine Arts (1933), ultimately exerting a strong impact as a teacher on various future Abstract Expressionists.

Peggy Guggenheim's Art of This Century granted Hofmann his New York debut (1944); subsequently he showed annually at Kootz Gallery from 1947 onwards until his death. In the late 1950s Hofmann began to attain his greatest originality in paintings saturated with color organized either in rectangular planes, free-flung swathes or a vigorous combination of both. The Whitney Museum of American Art organized a major traveling retrospective in 1957; the next year he finished teaching to devote himself to his art. Hofmann died in New York on 17 February, 1966.

FRANZ KLINE (1910—62)

Born to Anglo-German stock in the Pennsylvania coal-mining town of Wilkes Barre in 1910, Franz Kline's childhood was overshadowed, like Guston's, by his father's suicide. He went to Girard College (1919—25), Lehighton High School and Boston College, where he studied painting (1931—33). An interest in illustration and deft draftsmanship developed while Kline attended Heatherley's Art School in London, where he married Elizabeth Vincent Parsons. Kline moved to New York City in 1939 and began to paint cityscapes, yet the rough Appalachian landscape and industry of his childhood also imbued his outlook.

As avant-garde American art veered towards abstraction, so Kline increasingly broke away from figuration, especially under de Kooning's influence in the late

1940s (the two had met in 1943). A decisive shift came when Kline enlarged his sketches with a Bell Option opaque projector, recognizing their elemental potential. By 1950, Kline's bold brushstrokes of black-and-white, careering impulsively across the canvas, established his signature style. These were the works first shown at Charles Egan Gallery, New York (1950), announcing him as a major force of Abstract Expressionism. Subsequently, critics discerned traces of Far Eastern calligraphy in Kline's methods. However, he drew equally on the tradition of the more painterly European masters, such as Rembrandt and Goya.

Besides being included in the Museum of Modern Art's seminal exhibition *The New American Painting*, Kline participated in two Venice Biennales (1956 and 1960) and taught at the innovative Black Mountain College, North Carolina. Although color reinvigorated the later work, and the density or openness of his designs varied considerably, Kline's distinctive style remained largely consistent until his premature death from a rheumatic heart condition on 13 May, 1962.

LEE KRASNER (1908—84)

Lena Krassner was born in Brooklyn, on 27 October, 1908, to Russian émigré parents. Leonore (as she preferred) graduated from P.S.72, Brooklyn, in 1921 and attended the arts-orientated Washington Irving High School (1923—26). Reputedly incorrigible, she entered the Women's Art School of Cooper Union, briefly studied at the Art Students League (1928) and thence the National Academy of Design (to 1932). Instead of teaching, Krasner chose the Public Works of Art Project until 1934, and then the Works Progress Administration.

In the late 1930s Krasner enrolled at the Hans Hofmann School of Fine Arts (1937—40), joined the American Abstract Artists in 1939, and became increasingly prominent in left-wing politics with the Executive Board of the Artists Union. She later denounced all three associations as regressive and programmatic. Indeed, her later expansive abstrac-

tions were a far cry from the schematic, Cubist-influenced manner that Hofmann encouraged. Initially, Pollock's influence stymied Krasner, but her self-confidence revived when the now-married couple moved to Springs, Long Island. Here she conceived the crowded hieroglyphic networks of her *Little Image* series (1946—47).

Collage predominated in Krasner's first solo show at the Betty Parsons Gallery (1951) and she continued to expand its potential: significantly, her last years saw new works created by pasting cut-outs from discarded canvases. Pollock's death in 1956 precipitated a period of fierce, emotional abstraction. In the late 1950s Krasner's approach favored large, arcing vectors and filigree patterns, in a tense opposition of delicacy and force.

A retrospective at the Whitechapel Art Gallery, London (1965) helped to raise Krasner's profile, which had been overshadowed by the fact of her being Pollock's widow. She joined Marlborough Gallery (1966), exhibited 23 large canvases at the University of Alabama-Tuscaloosa in 1967, and showed her clean-cut, color-laden paintings at the Whitney Museum of American Art in 1973. Eventually, the Museum of Modern Art recognized Krasner's status with a traveling retrospective, which arrived there shortly after her death on 19 June, 1984.

NORMAN LEWIS (1909—79)

Norman Wilfred Lewis was born to Bermudan parents in Harlem, New York, on 23 July, 1909. He graduated from New York Vocational High School and worked on a ship in South America from 1929 to 1931, before returning to paint at the Savage Studio of Arts and Crafts (1933) and study at Columbia University and John Reed Club Art School (1933—35). Between 1936 and 1939 he was with the Works Progress Administration, and, alongside Romare Bearden, Selma Burke and Beauford and Joseph Delaney, became a founding member of the Harlem Artists Guild in 1935.

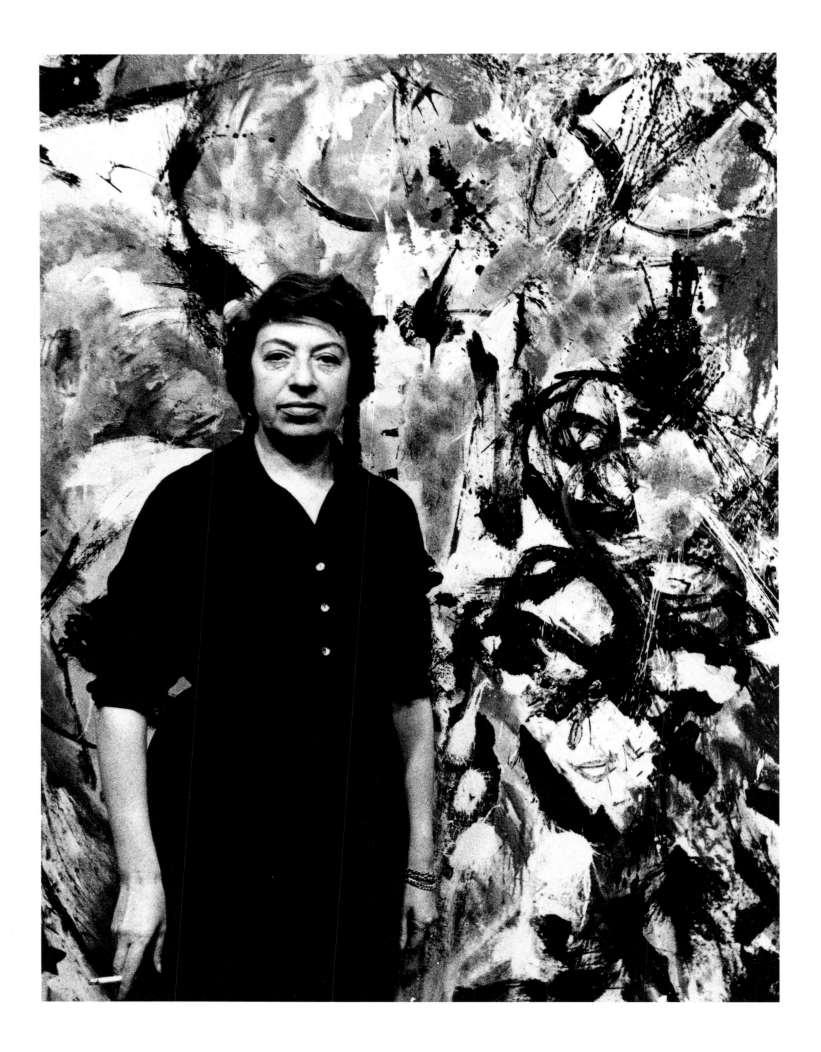

Opposite:
Lee Krasner,
Pace Gallery.
February 26, 1961

Franz Kline,
242 West 14th Street studio.
April 7, 1961

Robert Motherwell,
East 86th Street painting loft.
February 18, 1962

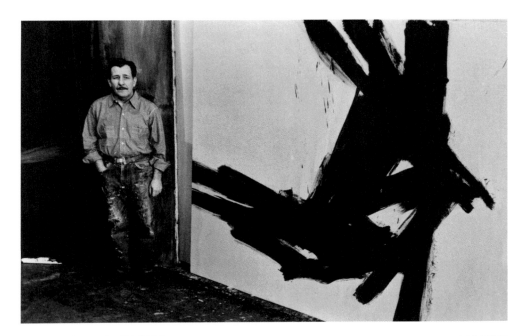

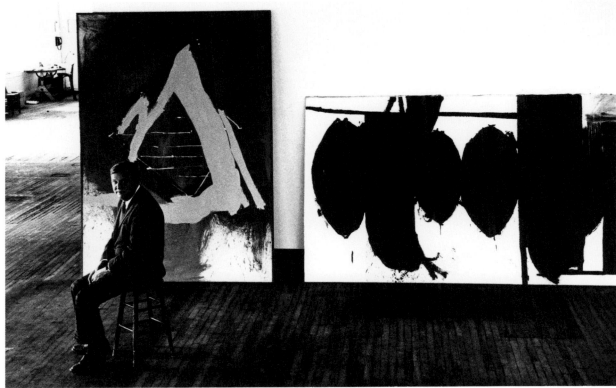

BIOGRAPHIES

Willard Gallery held a sequence of solo exhibitions from 1950 to 1960. During this period Lewis moved between gaudy, angular compositions, softer crepuscular fields and intensely rhythmic effects. He was politically active, picketing the Metropolitan Museum of Art, in protest over its controversial exhibition *Harlem On My Mind*, and was a founding member of the African-American Spiral group. Yet after the socialist realism of the 1930s phase, his paintings illustrated no explicit political agenda. Indeed, despite championing civil rights, Lewis described his so-called *Black Paintings* (1946—77) as purely formal variations. He also had a distinguished teaching career at George Washington Carver School (1943—44), Thomas Jefferson School of Social Science (1944—49), and at Harlem Youth in Action (1965—71) and the Art Students League (1972—79). Lewis died in New York on 27 August, 1979.

JOAN MITCHELL (1912—99)

Joan Mitchell was born in Chicago, Illinois, on 12 February, 1926. At Francis W. Parker School (1930—42) she pursued her talent for painting and poetry and met Barney Rosset Jr., whom she later married (1949—51). After two years reading English at Smith College, she won a scholarship to the Art Institute of Chicago (1944—47), graduating with a fellowship to study abroad. In France, Mitchell's vision imbibed the clean light and verdant landscape, with rich greens and blues vigorously stroked over white pictorial fields.

After returning to New York in 1949, Mitchell joined the Eighth Street Club (1951) and became close to Kline, de Kooning, and, especially, Frank O'Hara, whose poem *To the Harbormaster* inspired her eponymous painting. In 1953 New York's Stable Gallery mounted the first of several solo exhibitions (1953—66). Alongside Helen Frankenthaler, Grace Hartigan, and others, Mitchell appeared in the Jewish Museum's *Artists of the New York School* (1957), a celebration of second-generation Abstract Expressionism.

Mitchell moved to Paris in 1959 and eight years later bought a large estate in Vétheuil, near Monet's Giverny, where she lived the rest of her life. Her late style exalted in a lyrical palette and vigorous impasto, with nature replacing the urban landscape as an ever-constant source of inspiration. The Whitney Museum of American Art organized a travelling retrospective, in 2002. Mitchell died in Paris on 30 October, 1992.

BARBARA MORGAN (1900—92)

Barbara Brooks Johnson was born in Buffalo, Kansas, on 8 July, 1900. She studied art at the University of California at Los Angeles (1919—23), and after marrying the photographer and writer Willard Morgan in 1925, returned there to teach design and printmaking (1925—30). Morgan met the dancer Martha Graham in 1935; over the next six years she took ecstatic images of the choreographer at her most exuberantly gestural, freezing impetuous energy into bold ideograms. Her exhibition, *Dance Photographs*, at Black Mountain College (1940), and the book of photos she designed and published, *Martha Graham: Sixteen Dances in Photographs* (1941), remain landmarks in the photographic treatment of dance.

What Morgan called 'visual semantics' pervaded the abstract photomontages, photograms and light drawings made in the late 1940s and 1950s, which explore motion, trace and pattern. According to Morgan, in 'this largely mysterious universe... all that lives, moves.' Another side appeared in her stark images of childhood. Morgan held one-person exhibitions at, notably, the Museum of Modern Art (1945), in Prague (1947) and Paris (1964). In her later years, Morgan delivered many seminars on modern photography and became a Fellow of the Philadelphia Museum of Art in 1970. She was one of the artists chosen for the International Center of Photography's *Recollections: Ten Women of Photography* (1978). In 1988 the American Society of Magazine Photographers presented Morgan with a Lifetime Achievement Award. She died in Tarrytown, New York, on August 17, 1992.

ROBERT MOTHERWELL (1915—91)

Robert Burns Motherwell III was born in Aberdeen, Washington, on 24 January, 1915. The wealthy family lived in Salt Lake City, Utah, from 1919 to 1926, before moving to California where Motherwell gained a fellowship to the Otis Art Institute, Los Angeles. He studied briefly at the California School of Fine Arts, San Francisco (1932), and gained a degree in philosophy from Stanford University (1932—37). In 1938, after a graduate year at Harvard University, he spent another painting in Paris. Once back in New York, he studied art history with Meyer Schapiro at Columbia University (1940—42).

A trip to Mexico in 1941 with the Surrealist artist Roberto Matta proved decisive. Upon his return, Motherwell abandoned academic study for 'automatic' drawings. Innovative collages featured in his first solo show at Art of This Century (1944). In the same year Motherwell became series editor of the *Documents of Modern Art*. Erudite and committed to 'internationalism', Motherwell proved the leading spokesperson for the New York avant-garde. In 1948 he hit upon the prototype for his *Elegy to the Spanish Republic* series: ominous black columnar presences and ovoids often galvanized with incidents of stronger color. Throughout a long career, Motherwell constantly developed and refined the *Elegies*, enlarging the concept to epic grandeur. He also branched into further series, including the *Iberia* and *Summertime in Italy* works on canvas and paper and the *Opens*, with their vast expanses of unmodulated color. His prolific collages rank among the greatest achievements of the twentieth century in this medium.

Motherwell taught at Black Mountain College (1945 and 1951), spent a decade at Hunter College (1950—59), and in 1958 married Helen Frankenthaler. From the 1960s onwards, exhibitions throughout Europe and North America — as well as a mural commission for the National Gallery of Art, Washington D.C. (1977) — firmly cemented Motherwell's standing as a major, albeit younger, Abstract Expressionist. He died in Cape Cod, Massachusetts, on 16 July, 1991.

HANS NAMUTH (1915—90)

Hans Namuth was born in Essen, Germany, on 17 March, 1915. He studied at Humboldt Oberrealschule (1925—31) and took classes at the Museum Folkwang (1930—31), but was forced to flee to Paris in 1933 because of his involvement with the anti-Nazi German Youth Movement. Two years later he met the photographer Georg Reiner. The pair's assignment in Barcelona coincided with the outbreak of the Spanish Civil War in 1936, which they documented for *Vu* in images that mark an early waystage in Namuth's preoccupation with capturing figures in action.

The Second World War found Namuth interned in Paris, but he managed to escape and reach New York City in 1941. He then worked for the army (1943—45), before journeying to Guatemala in 1946. The photographs he took were shown at the Museum of Natural History in 1948. The following year his formal training recommenced at the New York School for Social Research under the tutelage of Alexey Brodovitch, whose involvement with *Harper's Bazaar* led to numerous advertising commissions.

The iconic photographs of Jackson Pollock at work happened in the summer of 1950 in Long Island. A film followed later that year and was shown at the Museum of Modern Art, in 1951. Namuth's rapport with his subject yielded images that suggested a fusion between the artist's bodily movements and his creations, thus contributing to the powerful mythology of 'action painting'. While influenced by August Sander's precedent, Namuth's portraiture was remarkably varied; the Castelli Gallery devoted separate exhibitions to his American (1975), Guatemalan (1977) and Spanish Civil War (1979) periods. Between 1979 and 1983 he had nineteen covers for *ArtNews*. Like Pollock, Namuth died in a car crash — on 13 October, 1990.

BIOGRAPHIES

Ad Reinhardt,
732 Broadway Studio.
March 1, 1961

Barnett Newman,
in his warehouse.
April 2, 1961

Richard Pousette-Dart,
Suffern studio.
February 22, 1962

Page 143:
David Smith,
sculpture installation,
Marlborough-Gerson Gallery,
East 57th Street.
October 17, 1964

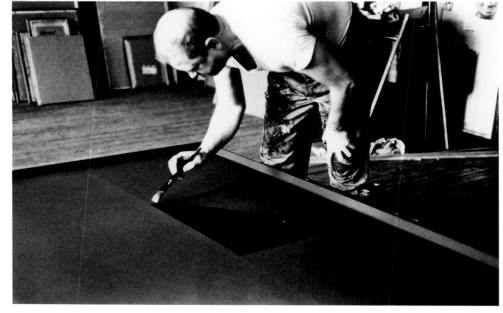

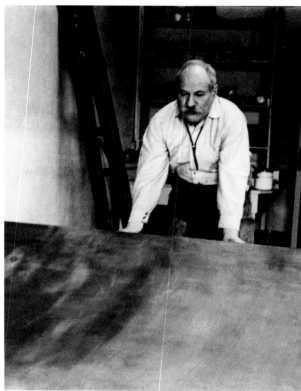

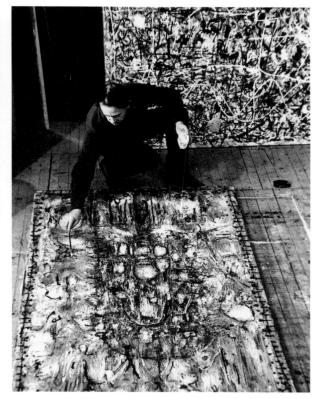

BARNETT NEWMAN (1905—70)

Born to Russian-Polish immigrants in Manhattan, on 29 January, 1905, Barnett Newman was brought up in Tremont, a relatively affluent area of the Bronx. He attended Hebrew school, then transferred in 1919 to DeWitt Clinton High School. He met Gottlieb at the Art Students League (1923) and studied philosophy at the City College of New York, graduating in 1927.

After the Wall Street Crash Newman helped his father Abraham to rebuild the family clothing business. He married Annalee Greenhouse in 1936, taught for several years, and spent leisure time at the American Museum of Natural History. In 1933, the spirited Newman even stood for mayor of New York.

In the mid-1940s Newman emerged as a prolific writer, advancing in essays and other texts his concepts of a sublime modern abstraction catalyzed by historical crisis. In 1948 Newman painted *Onement I*, a breakthrough leading to a particularly fertile creative phase. Yet his solo shows at Betty Parsons Gallery (1950, 1951) met with general incomprehension. Nevertheless, Newman continued to explore his distinctive amalgam of commanding chromatic expanses parsed with vertical elements, subsequently known as 'zips'.

Following a heart attack in 1957, Newman began a series of austere black-and-white canvases which would become the fourteen *Stations of the Cross*. In 1958 Bennington College, Vermont, held a retrospective. When *Newman-De Kooning* (1962) opened at Allan Stone Gallery, Newman's critical fortunes were in the ascendant, as his reductively forthright style seemed to herald a bold new esthetic. His later output included several monumental sculptures and two triangular canvases. Knoedler & Co. gave Newman his first solo show in ten years in 1969. He died of another heart attack on July 4, 1970.

JACKSON POLLOCK (1912—1956)

Paul Jackson Pollock was born in Cody, Wyoming, on 28 January, 1912. Pollock's childhood was affected by his domineering mother and his extended family's restlessness: between 1913—24 they changed homes numerous times. Having settled in Riverside, California (1924), Pollock attended high school there (1927—28), but was expelled for being rowdy. Already troubled by alcoholism and insecurity, he soon met a similar fate at Manual Arts High School in Los Angeles. However, by late 1930 Pollock had found a trusty mentor in Thomas Hart Benton, his teacher at the Art Students League.

During the 1930s Pollock worked on various federal relief programs and rapidly absorbed diverse influences — ranging from Benton's Regionalism to the Mexican muralists, Surrealism, native North American Indian art and Jungian psychology. In 1943 Peggy Guggenheim gave Pollock his first solo show at Art of This Century. Two years later, he married Lee Krasner and they moved to Springs, Long Island, where his working methods changed decisively. Famously, Pollock now placed his canvases on the floor, encircling them as he poured, dribbled and flicked liquid pigment. The results were snaking linear labyrinths composed of skeins of paint that seemed to evoke boundless spaces, flux and energy.

In 1949, a skeptical *Life* magazine article asked: 'Jackson Pollock: is he the greatest living painter in the United States?' Soon, and notably with the critic Clement Greenberg's advocacy, this claim had turned into a self-fulfilling prophecy. Moreover, Hans Namuth's photographs and film of Pollock at work would help to build the influential mystique of 'action painting,' in which the artist's body and gestures assumed priority over the finished painting. From late 1950 onwards, Pollock's alcoholism resurfaced, as did remnants of figuration in his increasingly sporadic work. In 1956 MoMA was planning a mid-career show: this became a memorial retrospective when Pollock died in a reckless car crash on 11 August, 1956.

BIOGRAPHIES

RICHARD POUSETTE-DART
(1916—92)

Richard Warren Pousette-Dart was born on 8 June, 1916, in St. Paul, Minnesota. At an early stage his parents, themselves creative figures in their own right, encouraged him to paint. As a youth, Pousette-Dart attended Bard College (1936), but abandoned his studies and settled in New York City in 1937 to single-mindedly make art.

Pousette-Dart's first one-man exhibition was at Artists' Gallery (1941), followed by *Forms in Brass*, a solo show at Willard Gallery (1943). This original early output combined the totemic, atavistic motifs and symbols of indigenous African and Oceanic art with the verve of European modernism. Moreover, Pousette-Dart was painting on a precociously large scale.

Pousette-Dart participated in the annual exhibition at the Federation of Modern Painters and Sculptors between 1944 and 1949. He married Evelyn Gracey in 1946 and in 1947 had a show at Art of This Century. Moving to Sloatsburg, New York, in 1951, he lectured at the School of the Museum of Fine Arts, Boston, and won a Guggenheim Fellowship. Subsequently he taught at various New York institutions, including the New School for Social Research (1959—61), Columbia University (1968—69) and the Art Students League (1980—85).

From the early 1950s onwards, Pousette-Dart's vision aimed for a transcendental mode of abstraction, as the mythic overtones of the previous decade gradually segued to mystical drifts of glowing color and timeless geometric emblems, increasingly rendered with myriad meticulous dabs of thick pigment. In 1963 The Whitney Museum of American Art gave the artist a retrospective. In 1982 he exhibited in the main pavilion at the Venice Biennale. A major traveling retrospective was organized by the Indianapolis Museum of Art in 1990. Pousette-Dart died in Rockland County on 25 October, 1992.

AD REINHARDT
(1913—67)

Adolph Dietrich Friedrich Reinhardt was born to Russian-German parents on 24 December, 1913, in Buffalo. He attended P.S. 88 (1919—28) and later Newton High School, both in Queens. A succession of influential teachers at Columbia University, (Meyer Schapiro, 1931—35), the National Academy of Design (Karl Anderson and John Martin, 1936), and the American Artists School (Carl Holty and Francis Criss, 1936—37) nurtured his talent for illustration and collage alongside his philosophical awareness, which was particularly drawn to Oriental art and thought.

Reinhardt showed with the American Abstract Artists in 1938 and was included in an exhibition at Art of This Century (1943). One-person shows were held at Artists' Gallery (1944), and Art School Gallery, Brooklyn Museum (1946), between which he was posted on the Pacific coast with the US Navy. By 1946, Reinhardt also regularly showed with Betty Parsons Gallery.

While at the Institute of Fine Arts, New York University (1946—51), Reinhardt refined his hazy, geometrically layered paintings, nevertheless still simultaneously penning witty polemical cartoons and articles for left-wing journals. Notwithstanding, his belief in abstract art's autonomy waxed unshakeable: 'Art is art. Everything else is everything else.' Starting in 1950, Reinhardt systematically purged his painting down to velvet-smooth surfaces, symmetry, monochrome (at first, red and blue) and, ultimately, blackness, in a steadfast pursuit of the absolute. He died on 30 August, 1967.

MARK ROTHKO
(1903—70)

Born on 25 September, 1903, in what was then Russian Latvia, Marcus Rothkowitz migrated to America with his family at the age of ten. He attended Yale

(1921—23), but left without a degree to settle in New York City, where he enrolled at the Art Students League under Max Weber. His first solo exhibition at the Portland Art Museum happened the same year, 1933, as another at Contemporary Arts Gallery, New York. Having subsequently become friends with Gottlieb and Newman, Rothko gravitated from somber Expressionist interior and urban scenes towards mythological tableaux. By the late 1940s, he had gone beyond representation altogether.

In 1950 Rothko attained his classic style. Ranging from brilliance to gloom, his signature image of several tiered rectangular presences hovering upon or within a colored continuum ranks among the most recognizably memorable of all Abstract Expressionist idioms. Rothko rang innumerable variations upon this idea, remarkable alike for their technical variety and spiritual aura. Rothko himself regarded the works in existential terms, insisting that they expressed 'basic emotions: tragedy, ecstasy, doom'. Commissioned in 1958 to paint vast murals for a new restaurant in the Seagram Building, New York, Rothko eventually withdrew from the project feeling that such a setting was deeply inappropriate.

Rothko had a large solo exhibition at the Museum of Modern Art (1961), and next painted murals for Harvard University (1962). But his aspiration to engage the beholder climaxed in the fourteen somber canvases for a non-denominational chapel in Houston, inaugurated posthumously in 1971. These huge imageless icons approach a monochromatic point of no return. They leave the easel picture behind to establish an architectonic environmental space. In his final years, depression dogged Rothko — a mood reflected in his severe late canvases, which nonetheless were created alongside many vivid paintings on paper — and he committed suicide on February 25, 1970.

CHARLES SELIGER
(1926—)

Charles Marvin Zekowski was born to an Austrian-Turkish mother and Polish-Hungarian father on 3 June, 1926. After their divorce in 1928, he lived with his grandmother, before joining his mother in 1931 in Baltimore, whence they moved to Cedarhurst, New York, and the Bronx. At fourteen he assumed her maiden name and they relocated to Jersey City. He was forced to work in a photography studio before finishing school, but continued to paint and draw; in 1945 his exotic, Surrealist-influenced canvases were shown at Art of This Century. By the late 1940s Seliger had formulated exquisitely realized palimpsests evoking the intricate structures of organic growth. Solo shows were held at Willard Gallery (1950), and Seligman Gallery, Seattle (1955).

Seliger's interest in the paradigms of science, psychology, botany and other complex disciplines has produced a vision that conflates expansive imaginative horizons with microscopic ones, offering a rejoinder to mainstream Abstract Expressionism's machismo and large dimensions. Favoring acrylic as a medium, the looser idiom of the 1960s and 1970s has segued to an intense, jeweled and painstakingly delineated late style. In 2003 Seliger received the Lee Krasner Lifetime Achievement Award. Seliger continues to exhibit regularly with Michael Rosenfeld Gallery, New York.

AARON SISKIND
(1903—91)

Aaron Siskind was born to Russian-Jewish immigrants on 4 December, 1903, in New York. He attended DeWitt Clinton High School (1915—22), and as a zealous adolescent joined the Young People's Socialist League. He studied literature at City College, New York (1922—26), and taught English at various institutions until 1947. After receiving a camera from his wife, Sidonie Glaller, he became a social documentarian for New York's Film and Photo League (1932—41). Fascinated with the medium *per se*, he moved from the figure towards stylized metaphorical forms and striking textures discovered on the streets around him. This abstract approach earned him a reputation among the burgeoning New York School, including Kline and de

Kooning, whose wife Elaine wrote the introduction to the photographer's exhibition at Charles Egan Gallery in 1951. The enigma, drama, grittiness and immediacy of Siskind's images allied him closely with Abstract Expressionist painting.

Siskind was a prominent spokesperson for avant-garde photography: he wrote 'Credo' for Edward Steichen's survey of modern photography at the Museum of Modern Art (1951), was a founder member of the Society for Photographic Education (1963), and for ten years co-edited *Choice*, a photography and literature journal (1960—70). His prolific career as a photography professor began at Trenton Junior College, New Jersey (1947—49), then Black Mountain College, North Carolina (1951). At the invitation of his friend Harry Callahan, he moved to the Institute of Design in Chicago (1951—71), and the pair were reunited at the Rhode Island School of Design, Providence, where he taught until his retirement in 1976. Siskind died in Providence on 8 February, 1991.

DAVID SMITH (1906—65)

David Roland Smith was born on 9 March, 1906, in Decatur, Indiana. The professions of his father and grandfather, respectively an inventor and blacksmith, allied to the manifold evidence of America's first machine age prompted his lifelong fascination with iron, steel and machinery. In 1921 the family moved to Paulding. Smith briefly attended university, but found his creativity thwarted and returned to the Studebaker automobile factory in South Bend, Indiana, a year later. He moved to New York from Washington D.C. in 1926, and met his first wife, the artist Dorothy Dehner. In New York he enrolled at the Art Students League (1926—32) and was taught by, among others, the Czech modernist Jan Matulka, who stimulated his appreciation for the work of Pablo Picasso and Julio González. Shortly after, a forge and anvil were installed in his Bolton Landing studio, and in 1933 he began welding heads from iron.

After his first solo show at East River Gallery (1938), Smith worked mainly in steel. Favoring abstraction over social realism, his solo exhibition at Neumann-Willard Gallery (1940) drew praise from Clement Greenberg. Declared unfit for war, from 1944 onwards he devoted himself to sculpture. In 1950, Smith won a John Simon Guggenheim Memorial Foundation Fellowship, which bolstered the resources and inspiration for him to formulate a mature sculptural syntax.

During the 1950s and 1960s Smith's fecundity grew, as he made such series as the *Agricolas*, *Sentinels*, *Tanktotems*, *Zigs*, *Voltris*, *Voltri-Boltons* and *Cubis* — not to mention a prolific body of works on paper. In 1957 the Museum of Modern Art held a major retrospective, and a year later he was the United States representative at the Venice Biennale. An extraordinary 30-day burst of activity in Spoleto, Italy, in the summer of 1962, spawned 27 *Voltri* sculptures. The monumental, gleaming steel of the *Cubi*s ensued, but the new direction signaled by *Becca* and *Untitled (Candida)* (1965) was tragically terminated: Smith died in a car accident on 23 May, 1965.

FREDERICK SOMMER (1905—99)

Fritz Carlos Sommer was born to Swiss-German parents in Angri, Italy, on 7 September, 1905. The family moved to São Paulo, Brazil, in 1913, and he was taught at the Deutsche Schule zu Vila Mariana (1913—16). He continued his studies in Rio de Janeiro at the Colégio Cruzerio (1916—20), but did not graduate from Ginásio de São Paulo (1920—22), preferring instead to draw for his father's city planning firm. In the summer of 1925, Sommer emigrated to America. Encouraged by Edward Gorton Davis, he enrolled at Cornell University, Ithaca, and gained a Masters degree in landscape architecture in 1927.

During the 1930s Sommer and his wife, Frances Elisabeth Watson, alternated between Arizona and New York, a time when his friendships with Alfred Stieglitz, Edward Steichen, Edward Weston, and

Max Ernst encouraged his move toward photography that was at once lyrical and disturbing. His images varied from landscapes claustrophobically packed with tiny detail to unblinking studies of animal carcasses and even human body parts. Solo shows included those at Howard Putzel Gallery (1937), Santa Barbara Museum of Art, California (1946), Charles Egan Gallery (1949), the Art Institute of Chicago (1963) and Philadelphia College of Art (1968). The Frederick and Frances Sommer Foundation was established in 1993. He died in Prescott, Arizona, on 23 January, 1999.

CLYFFORD STILL (1904—80)

Born in Grandin, North Dakota, on 30 November, 1904, Clyfford Elmer Still moved with his family to a homestead in Alberta, Canada, when he was two years old. He attended Spokane University (1926 and 1931—33), when he met his first wife Lillian Battan, and studied art, philosophy and literary criticism for a Masters degree at Washington State College, Pullman (1933—35), where he also taught until 1941. Other than a brief sojourn at the Art Students League (1925), and two summers at the Trask Foundation (now Yaddo; 1934 and 1935), Still's imperious sensibility developed largely in isolation. Between 1941 and 1943 he worked in defense industries, before the San Francisco Museum of Art gave him his first solo exhibition at the age of 39.

Still's art grew rapidly in scale, ambition and extremity between his departure in 1945 from Richmond Professional Institute (now Virginia Commonwealth University) and his move to a farm in Maryland in 1961. The artist saw these splintered, imploded expanses of color — sometimes exploiting bare canvas and always rendered with the palette knife — as physical embodiments of a strong ethical drive. He also produced many oils, pastels and drawings on paper. Still's uncompromising stance, combined with his caustic view of the art world and its players, made him a perennial outsider. Nevertheless, Still agreed to exhibit his brooding, semi-figurative

canvases at Art of This Century (1946). Further solo shows followed at Betty Parsons Gallery (1947, 1950, and 1951). In 1959 the Albright-Knox Art Gallery, Buffalo, held a decisive retrospective. The American Academy of Arts and Letters gave Still the Award of Merit in 1972, electing him a member six years later. In 1979 he had a massive retrospective at the Metropolitan Museum of Art. The University of Maryland awarded Still an honorary doctorate a month before his death from cancer on 23 June, 1980.

MARK TOBEY (1890—76)

Mark George Tobey was born in Centreville, Wisconsin, on 11 December, 1890. He attended high school in Hammond, Indiana, traveling to Chicago for weekend painting classes at the Art Institute (1906—08). When the family set up home there he was required to take work in a fashion studio (1909—11), marking the end of his formal training. At 21 Tobey moved to Greenwich Village, where he worked as a fashion illustrator for *McCall's* magazine and made charcoal portraits that were shown in his first solo debut at Knoedler & Co. (1917).

Eastern philosophy impacted on Tobey's sensibility from an early age: in 1918 he converted to the Baha'i Faith — its emphasis on the oneness of humanity is visually paralleled in the all-over totality of his mature compositions. From 1923 Tobey taught at the Seattle Art Museum and was the artist-in-residence at Dartington Hall in Devon, England (1931—38). During this time he traveled to Shanghai and Japan and developed the 'white-writing' style for which he is renowned. The meditative introversion of these often small images is markedly different from the flamboyance characterizing much, albeit not all, Abstract Expressionism.

Tobey returned to Seattle in 1938 to paint and compose music. A solo show was held at Willard Gallery in 1944, followed in 1951 by a joint exhibition at the Museum of Modern Art, San Francisco, and

the Whitney Museum of American Art. Tobey twice exhibited at Documenta, Kassel (1959, 1964). Perhaps most impressively, in 1958 he became the first American since Whistler to receive the Grand Prize at the Venice Biennale. Tobey moved to Basel in 1960 and had a show at the Musée des Arts Décoratifs in Paris the following year, as well as exhibitions at the Museum of Modern Art (1962), and the Stedelijk Museum (1966). He died in Basel on 24 April, 1976.

JACK TWORKOV (1900—82)

Jacob Tworkovsky was born in 1900 in Biala, Poland, and in 1913 his family came to New York. Despite training as a writer at Columbia University (1920—23), his encounter with European modernist paintings at various museums in the city led him to the National Academy of Design (1923—25) and the Art Students League (1925—26). In 1928 Tworkov took American citizenship; his work still bore the influence of Kandinsky, Cézanne and Miró.

During the Depression Tworkov worked for the easel division of the Works Progress Administration, and in 1940 had his first solo show at ACA Gallery. During the war he stopped painting, but resumed with a distinctive gestural style of dashing, incisive and rhythmical brushstrokes. This work was exhibited widely, including several shows at Charles Egan Gallery (1947—54), and Stable Gallery (1957—59).

Tworkov was a founding member of The Club, an avant-garde forum in New York in the 1950s. He taught variously at Queens College (1948—51), Black Mountain College (1952), and the Pratt Institute (1955—58), and in 1963 became chairman of the art department at Yale University (until 1969). At the end of the 1960s Tworkov abandoned his extrovert gesturalism in favor of carefully poised grids. He held important late exhibitions at the Whitney Museum of American Art (1964, 1971) and the Rhode Island School of Design (1980). Tworkov died in Provincetown, Massachusetts, in 1982.

MINOR WHITE (1908—76)

Minor Martin White was born in Minneapolis, on 9 July, 1908. At the age of eight, he was given a Box Brownie and took photographs in his grandmother's garden, which perhaps influenced his decision to study botany at the University of Minnesota (1929—33). During the Depression, White did odd jobs and wrote poetry, spending five years on a sequence of 100 sonnets. In 1938 he moved to Portland, Oregon, to work for the Works Progress Administration. He was appointed director of La Grande Art Center, Oregon in 1940. During the war he worked for military intelligence in the Philippines, returning to America in 1945, first to study at Columbia University (1945—46) then, at Ansel Adams's invitation, to teach at the California School of Fine Arts, San Francisco (1946—53). The San Francisco Museum of Art mounted White's first major show in 1948; in 1952 he co-founded *Aperture* with Adams and six others.

Adams's technical virtuosity and the erotic aura of Edward Weston and Alfred Stieglitz's work strongly affected White's sensibility. Indeed, he developed in the tradition of Stieglitz's theory of 'equivalents' — the notion that photographs should 'yield an image with specific suggestive powers that can direct the viewer into a specific known feeling...' White's own compositions exude a vivid beauty: nature is transfigured into realms of radiance, abstract exactitude and quiescent motion. Other studies of the figure reflected White's homosexuality. His belief that the camera is 'first a means of self-discovery' relates him to the tenets of Abstract Expressionism.

As well as creating hypnotic photographs, White was a generous teacher. After being a curator at George Eastman House, Rochester (1953—56), he took a position at Rochester Institute of Technology (1956—64), and later the Massachusetts Institute of Technology (MIT), providing brilliant, if dogmatic, expositions of, among other matters, the *Zone system* technique developed by Adams and Fred Archer in 1941. White died on 24 June, 1976.

LIST OF WORKS

WILLIAM BAZIOTES

01. *Mariner*, 1960—61
Oil on canvas, 66 × 78 in (167.5 × 198 cm)
Blanton Museum of Art, The University of Texas at Austin.
Gift of Mari and James A. Michener, 1991. © Estate of William
Baziotes. Courtesy Blanton Museum of Art, The University
of Texas at Austin. Photo: Rick Hall

HARRY CALLAHAN

02. *Lake Michigan*, 1950
Gelatin silver print, 5 × 6 ½ in (12.5 × 16.5 cm)
© The Estate of Harry Callahan.
Courtesy Pace/MacGill Gallery, New York

WILLEM DE KOONING

03. *Untitled*, 1961
Oil on canvas, 80 × 70 in (203 × 178 cm)
Rose Art Museum, Brandeis University. Gift of Joachim Jean
and Julian J. Aberbach. © 2008 The Willem de Kooning
Foundation/Artists Rights Society (ARS), New York.
Courtesy Rose Art Museum, Brandeis University, Waltham

04. *Triptych (Untitled V, Untitled II, Untitled IV)*, 1985
Oil on canvas, three panels. Left panel 80 × 70 in
(203 × 178 cm); central panel 77 × 88 in (195.5 ×
452 cm); right panel 80 × 70 (203 × 178 cm)
Private Collection. © 2008 The Willem de Kooning Foundation/
Artists Rights Society (ARS), New York. Courtesy Foundation
H. Looser, Zürich

05. *Abstraction*, c.1949
Oil on canvas, 24 ½ × 32 ½ in (62 × 82.5 cm)
Private Collection, Palm Beach. © 2008 The Willem de Kooning
Foundation/Artists Rights Society (ARS), New York

06. *Untitled IV*, 1978
Oil on canvas, 70 ¼ × 80 ¼ in (178.5 × 204 cm)
Private Collection. © 2008 The Willem de Kooning Foundation/
Artists Rights Society (ARS), New York. Courtesy of Gagosian
Gallery and Thomas Ammann Fine Art AG

07. *Hostess*, 1973
Bronze, 49 × 37 × 29 in (124.5 × 94 × 73.5 cm)
Private Collection. © 2008 The Willem de Kooning Foundation/
Artists Rights Society (ARS), New York. Courtesy of Gagosian
Gallery and Thomas Ammann Fine Art AG

SAM FRANCIS

08. *Study for Shining Back*, 1958
Watercolor on paper, 40 × 27 in (101.5 × 68.5 cm)
Neuberger Museum of Art, Purchase College, State University
of New York. Gift of Roy R. Neuberger. © 2008 Samuel L. Francis
Foundation, California/Artists Rights Society (ARS), New York.
Courtesy Neuberger Museum of Art, Purchase College, State
University of New York

09. *Blue-Black*, 1952
Oil on canvas, 117 × 76 ½ in (297 × 194.5 cm)
Albright-Knox Art Gallery, Buffalo. Gift of Seymour H. Knox, Jr.,
1956. © 2008 Samuel L. Francis Foundation, California/Artists Rights
Society (ARS), New York. Courtesy Albright-Knox Art Gallery, Buffalo

10. *Untitled*, 1959
Oil on canvas, 96 × 116 ½ in (244 × 296 cm)
Art Gallery of Ontario, Toronto. Gift from the Women's
Committee Fund, 1960. © 2008 Samuel L. Francis Foundation,
California/Artists Rights Society (ARS), New York.
Courtesy Art Gallery of Ontario, Toronto

ARSHILE GORKY

11. *Untitled*, 1943
Graphite and wax pencil on paper
18 × 24 ½ in (52.7 × 70.3 cm)
Centro de Arte Moderna José de Azeredo Perdigão, Fundação
Calouste Gulbenkian. © 2008 Artists Rights Society (ARS),
New York. Courtesy Centro de Arte Moderna José de Azeredo
Perdigão, Fundação Calouste Gulbenkian

12. *The Pirate I*, 1942 or 1944
Oil on canvas, 29 × 40 in (75 × 104 cm)
Collection of John McEnroe. Courtesy Waqas Wajahat, New York.
© 2008 Artists Rights Society (ARS), New York

13. *Year after Year*, 1947
Oil on canvas, 34 × 39 in (86.5 × 99 cm)
Private Collection. © 2008 Artists Rights Society (ARS), New York

ADOLPH GOTTLIEB

14. *Composition*, 1945
Oil, gouache, casein and tempera on linen
29 ¾ × 35 in (75.5 × 89 cm)
Adolph & Esther Gottlieb Foundation, New York.
© The Adolph and Esther Gottlieb Foundation/
Licensed by VAGA, New York, NY

15. *Levitation*, 1959
Oil on linen, 90 × 60 in (228.5 × 152.5 cm)
Private Collection. © The Adolph and Esther Gottlieb
Foundation/Licensed by VAGA, New York, NY. Courtesy
Adolph & Esther Gottlieb Foundation, New York, NY

16. *Green Turbulence*, 1968
Acrylic on canvas
94 × 157 in (239 × 399 cm)
Private Collection. © The Adolph and Esther Gottlieb
Foundation/Licensed by VAGA, New York, NY. Courtesy
Adolph & Esther Gottlieb Foundation, New York, NY

PHILIP GUSTON

17. *Downtown*, 1969
Oil on canvas, 40 × 48 in (101.5 × 122 cm)
Collection of John McEnroe. Courtesy Waqas Wajahat, New York.
© Estate of Philip Guston

HANS HOFMANN

18. *Pagliaccio*, 1964
Oil on canvas, 84 × 60 in (213.5 × 152.5 cm)
Private Collection. © 2008 Renate, Hans & Maria Hofmann Trust/
Artists Rights Society (ARS), New York

FRANZ KLINE

19. *Vawdavitch*, 1955
Oil on canvas, 62 × 80 in (157.5 × 203 cm)
The Museum of Contemporary Art, Chicago. © 2008
The Franz Kline Estate/Artists Rights Society (ARS), New York.
Courtesy The Museum of Contemporary Art, Chicago

LEE KRASNER

20. *Untitled*, 1949
Oil on panel, 48 × 24 in (122 × 61 cm)
Private Collection. © 2008 The Pollock-Krasner Foundation/
Artists Rights Society (ARS), New York.

21. *Another Storm*, 1963
Oil on canvas, 94 × 176 in (239 × 447 cm)
Private Collection. © 2008 The Pollock-Krasner Foundation/
Artists Rights Society (ARS), New York. Courtesy Robert Miller
Gallery, New York

NORMAN LEWIS

22. *Untitled*, 1946
Oil on canvas, 36 × 24 in (91.5 × 61 cm)
Michael Rosenfeld Gallery LLC, New York, NY.
© Estate of Norman Lewis. Courtesy Michael Rosenfeld
Gallery LLC, New York, NY

JOAN MITCHELL

23. *Untitled*, 1959
Oil on canvas, 77 × 64 in (195.5 × 162.5 cm)
Private Collection. © Estate of Joan Mitchell

BARBARA MORGAN

24. *Pure Energy and Neurotic Man*, 1941
Gelatin silver print, 19 × 15 ½ in (48.5 × 39.5 cm)
The Museum of Modern Art, New York. Gift of the photographer.
© Barbara Morgan, The Barbara Morgan Archive.
Courtesy Silverstein Photography, New York

25. *Light Waves*, 1945
Vintage silver print (photogram)
9 ½ × 7 in (24 × 18 cm)
© Barbara Morgan, The Barbara Morgan Archive.
Courtesy Silverstein Photography, New York

ROBERT MOTHERWELL

26. *Figure with Blots*, 1943
Oil, collage, gouache and charcoal on paper
45 ½ × 38 in (115.5 × 96.5 cm)
Private Collection. © Dedalus Foundation, Inc./
Licensed by VAGA, New York, NY

27. *Whatman Board Collage, PH-2-10*, 1966
Collage and oil on board, 39 × 27 in (99 × 68.5 cm)
Private Collection. © Dedalus Foundation, Inc./
Licensed by VAGA, New York, NY

28. *Beside the Sea with Gauloises*, 1967
Oil on Strathmore paper with charcoal signature
30 × 25 in (76 × 63.5 cm)
Private Collection. © Dedalus Foundation, Inc./
Licensed by VAGA, New York, NY

29. *Elegy to the Spanish Republic*, 1970
Acrylic on canvas, 82 ½ × 188 ½ in (209.5 × 479 cm)
Private Collection. © Dedalus Foundation, Inc./
Licensed by VAGA, New York, NY

HANS NAMUTH

30. *Jackson Pollock*, 1950
Gelatin silver print, 9 × 7 in (22.5 × 17.5 cm)
© 1991 Hans Namuth Estate. Courtesy Center for Creative
Photography, University of Arizona

LIST OF WORKS

BARNETT NEWMAN

31. *Untitled*, 1948
Brush and black ink on heavy cream wove paper
24 × 16 ½ in (61 × 42 cm)
Smith College Museum of Art, Northampton, Massachusetts.
Gift of Philip C. Johnson. © 2008 The Barnett Newman
Foundation, New York/Artists Rights Society (ARS), New York.
Courtesy Smith College Museum of Art, Northampton,
Massachusetts

32. *Moment*, 1946
Oil on canvas, 30 ⅛ × 16 in (96.5 × 40.5 cm)
Tate, London. © 2008 The Barnett Newman Foundation,
New York/Artists Rights Society (ARS), New York.
Courtesy Tate, London 2008

33. *End of Silence*, 1949
Oil on canvas, 38 × 30 in (96.5 × 76 cm)
Marsha and Jeffrey Perelman. © 2008 The Barnett Newman
Foundation, New York/Artists Rights Society (ARS), New York

34. *Untitled*, 1949
Oil on canvas, 74 × 29 in (188 × 73.5 cm)
Private Collection. Courtesy Knoedler & Company, New York

JACKSON POLLOCK

35. *Constellation (Accabonac Creek Series)*, 1946
Oil on canvas, 22 × 18 ½ in (56 × 47 cm)
Stephen Mazoh, Rhinebeck, NY. © 2008 The Pollock-Krasner
Foundation/Artists Rights Society (ARS), New York

36. *Number 19, 1949*, 1949
Enamel on parchment mounted on composition
board, 31 × 22 ½ in (78.5 × 57 cm)
Private Collection. © 2008 The Pollock-Krasner Foundation/
Artists Rights Society (ARS), New York

37. *Number 17, 1950 (Fireworks)*, 1950
Enamel and aluminum paint on composition board
22 ¼ × 22 ¼ in (56.5 × 56.5 cm)
Whitney Museum of American Art, New York. Gift of
Mildred S. Lee. © 2008 The Pollock-Krasner Foundation/
Artists Rights Society (ARS), New York. Courtesy Whitney
Museum of American Art, New York. Photo: Steven Sloman

38. *Untitled*, c.1951
Oil, enamel and pebbles on board
21 ¾ × 29 ½ in (55 × 75 cm)
Stephen Mazoh, Rhinebeck, NY . © 2008 The Pollock-Krasner
Foundation/Artists Rights Society (ARS), New York

39. *Untitled*, 1951
Ink and gouache on paper, 25 × 39 in (63.5 × 99 cm)
Scottish National Gallery of Modern Art, Edinburgh.
© 2008 The Pollock-Krasner Foundation/Artists Rights
Society (ARS), New York. Courtesy Scottish National
Gallery of Modern Art, Edinburgh

RICHARD POUSETTE-DART

40. *Time is the Mind of Space, Space is the Body of Time*,
1979—82
Acrylic on linen. Three panels. Each panel
89 ½ × 62 ½ in (227.5 × 159 cm)
© 2008 Estate of Richard Pousette-Dart/Artists Rights Society
(ARS), New York. Courtesy of The Estate of Richard Pousette-
Dart and Knoedler & Company, New York

AD REINHARDT

41. *Untitled*, 1950
Gouache on paper, 27 × 40 ¼ in (68.5 × 102 cm)
Montclair Art Museum. Museum purchase; prior gift of
Mrs. Frank L. Babbott, 1988. © 2008 Estate of Ad Reinhardt/
Artists Rights Society (ARS), New York. Courtesy Montclair
Art Museum

42. *Red Painting*, 1952
Oil on canvas, 60 × 82 in (152.5 × 208 cm)
Virginia Museum of Fine Arts, Richmond. Gift of Sydney and
Frances Lewis. © 2008 Estate of Ad Reinhardt/Artist Rights
Society (ARS), New York. Courtesy Virginia Museum of Fine
Arts, Richmond

MARK ROTHKO

43. *Untitled*, 1960
Oil on canvas, 69 × 50 in (175.5 × 127 cm)
San Francisco Museum of Modern Art. Acquired through
a gift of Peggy Guggenheim. © 1998 Kate Rothko Prizel and
Christopher Rothko/Artists Rights Society (ARS), New York

44. *Untitled*, 1968
Oil on paper mounted on canvas
39 ¾ × 25 ½ in (99 × 63.5 cm)
Private Collection © 1998 Kate Rothko Prizel and
Christopher Rothko/Artists Rights Society (ARS), New York

45. *Untitled*, 1968
Oil on paper mounted on canvas
38 ½ × 25 ½ in (99 × 63.5cm)
Private Collection © 1998 Kate Rothko Prizel and
Christopher Rothko/Artists Rights Society (ARS), New York

CHARLES SELIGER

46. *Multicellular Apparition*, 1946
Oil on canvas, 28 ¼ × 22 ½ in (72 × 57 cm)
© Charles Seliger 2008. Courtesy Michael Rosenfeld Gallery, LLC, New York, NY

47. *Boundless Worlds*, 2001
Acrylic on masonite, 10 × 18 in (25.4 × 45.5 cm)
© Charles Seliger 2008. Courtesy Michael Rosenfeld Gallery, LLC, New York, NY

AARON SISKIND

48. *Jalapa 46 (Homage to Franz Kline)*, 1973
Vintage silver print, 7 × 9 ½ in (18 × 24 cm)
© Aaron Siskind Foundation. Courtesy Silverstein Photography, New York

49. *Chicago*, c.1948
Vintage silver print, 24 × 20 in (61 × 51 cm)
© Aaron Siskind Foundation. Courtesy Robert Mann Gallery, New York

DAVID SMITH

50. *Voltri IV*, 1962
Steel, 68 ½ × 59 ½ × 14 ½ in (174 × 151 × 37 cm)
Kröller-Müller Museum, Otterlo, The Netherlands.
© Estate of David Smith/Licensed by VAGA, New York, NY.
Courtesy Kröller-Müller Museum, Otterlo, The Netherlands

51. *Voltri-Bolton V*, 1962
Steel dry-brushed with orange paint
81 × 41 × 11 in (205 × 104 × 28 cm)
Rena Bransten, San Francisco. © Estate of David Smith/
Licensed by VAGA, New York, NY. Courtesy Rena Bransten Gallery, San Francisco

52. *Tower Eight*, 1957
Silver, 46 ½ × 14 × 10 ½ in (118 × 35.5 × 26.6 cm)
Raymond and Patsy Nasher Collection, Dallas. © Estate of David Smith/Licensed by VAGA, New York, NY. Courtesy Raymond and Patsy Nasher Collection, Dallas

53. *Voltri-Bolton X*, 1962
Steel, 81 ¼ × 42 × 11 ¼ in (206.5 × 106.5 × 28.5 cm)
Private Collection. © Estate of David Smith/Licensed by VAGA, New York, NY

54. *Forging XI*, 1955
Steel, 91 × 8 ½ × 8 ½ in (231 × 21.5 × 21.5 cm)
Private Collection. © Estate of David Smith/Licensed by VAGA, New York, NY. Courtesy Julian Weissman Fine Art, LLC, New York

55. *Seven Hours*, 1961
Painted steel, 84 ¼ × 48 × 17 in (214 × 122 × 43 cm)
Private Collection. © Estate of David Smith/Licensed by VAGA, New York, NY. Courtesy Gagosian Gallery, New York

FREDERICK SOMMER

56. *Sumaré*, 1952
Gelatin silver print, 7 ½ × 9 ½ in (19 × 24 cm)
The Museum of Modern Art, New York. Gift of the photographer, 1969. © Frederick and Frances Sommer Foundation. Courtesy Frederick and Frances Sommer Foundation

CLYFFORD STILL

57. *Untitled 1953-No.2 (PH-847)*, 1953
Oil on canvas, 109 × 92 in (277 × 233.5 cm)
Private Collection. © The Clyfford Still Estate

58. *1955-M-No.2 (PH-776)*, 1955
Oil on canvas, 114 × 96 in (289.5 × 244 cm)
University of California, Berkeley Art Museum and Pacific Film Archive. © The Clyfford Still Estate. Courtesy University of California, Berkeley Art Museum and Pacific Film Archive

MARK TOBEY

59. *Yellow Harbor*, 1952
Tempera and crayon on brown paper
19 × 25 in (48.5 × 63.5 cm)
Private Collection, Germany. © Mark Tobey Estate/
Seattle Art Museum. Courtesy Fodera Fine Art and Michael Rosenfeld Gallery LLC, New York

60. *Desert Town (Wild City)*, 1950
Oil and gouache on card mounted on masonite
43 × 27 in (109 × 69 cm)
© Mark Tobey Estate/Seattle Art Museum.
Courtesy Moeller Fine Art, New York — Berlin

JACK TWORKOV

61. *Idling II*, 1970
Oil on canvas, 80 × 70 in (203 × 178 cm)
The Estate of Jack Tworkov. © The Estate of Jack Tworkov.
Courtesy Mitchell-Innes & Nash, New York

MINOR WHITE

62. *Surf, Vertical, San Mateo County, California*, 1947
Printed 1948
Gelatin silver print, 4 ½ × 3 ½ in (11.5 × 9 cm)
Center for Creative Photography, Tucson, Arizona. © Trustees of Princeton University. Reproduced with permission of the Minor White Archive, Princeton University Art Museum. Courtesy the Center for Creative Photography, Tucson, Arizona

Published on the occasion of the exhibition
Abstract Expressionism — A World Elsewhere
at Haunch of Venison New York,
12 September — 12 November 2008

Haunch of Venison

New York
1230 Avenue of the Americas, 20th Floor
New York, NY 10020
USA
T +1 212 636 2034
F +1 212 636 4959
newyork@haunchofvenison.com

London
6 Haunch of Venison Yard
off Brook Street
London W1K 5ES
United Kingdom
T +44 (0)20 7495 5050
F +44 (0)20 7495 4050
london@haunchofvenison.com

Zürich
Lessingstrasse 5
8002 Zürich
Switzerland
T +41 (0) 43 422 8888
F +41 (0) 43 422 8889
zurich@haunchofvenison.com

Berlin
Heidestrasse 46
10557 Berlin
Germany
T +49 (0) 30 39 74 39 63
F +49 (0) 30 39 74 39 64
berlin@haunchofvenison.com

www.haunchofvenison.com

Design: Marque Creative, New York
Reprographics: DawkinsColour, London
Print: Lecturis, Eindhoven

Essay © David Anfam, Art Ex Ltd 2008
Publication © Haunch of Venison 2008

Fred W. McDarrah photographs:
Pages 02—03: Franz Kline's studio at 242 West
14th Street, New York. April 7, 1961. Pages 08—09:
Hans Hofmann's 8th Street studio. February 27, 1960.
Page 24: Richard Pousette-Dart's studio. February 22,
1962. Page 126: Ad Reinhardt's studio. 732 Broadway,
March 1, 1961. All images © Fred W. McDarrah

Image credits, *A World Elsewhere*:
Page 13: *Weed Against Sky*. © The Estate of Harry
Callahan. Courtesy Pace/MacGill Gallery, New
York. Page 17: *Thru the Window*. © 1997 Christopher
Rothko and Kate Rothko Prizel/Artists Rights
Society (ARS), New York. Courtesy of the Board
of Trustees, National Gallery of Art, Washington;
Wasteland. Collection of the Adolph and Esther
Gottlieb Foundation © The Adolph and Esther
Gottlieb Foundation/Licensed by VAGA, NY;
Self-Portrait in the Wilderness. Collection of Andrew
J. Crispo © The Willem de Kooning Foundation/
Artists Rights Society (ARS), New York; *Untitled
(PH-323)*. San Francisco Museum of Modern Art
© The Clyfford Still Estate. Page 19: *The Night of the
Hunter*. © 1955 Metro-Goldwyn-Mayer Studios Inc.
All Rights Reserved. Courtesy of MGM CLIP+
STILL; *Number 1A, 1948*. © 2008 Pollock-Krasner
Foundation/Artists Rights Society (ARS), New York.
Courtesy the Museum of Modern Art, New York

Edition of 3000
ISBN: 978-1-905620-26-5